The Artist's Mother

The Greatest Painters Pay Tribute
to the Women Who Rocked Their Cradles

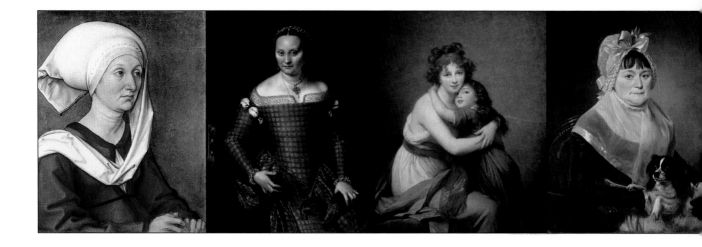

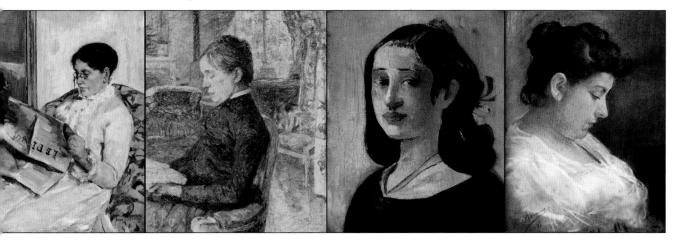

The Artist's Mother

The Greatest Painters Pay Tribute
to the Women Who Rocked Their Cradles

Introduction by Judith Thurman

Overlook Duckworth
New York & London

Published in in 2009 by
Overlook Duckworth, Peter Mayer Publishers, Inc.
New York & London

NEW YORK:
141 Wooster Street
New York, NY 10012

LONDON:
90-93 Cowcross Street
London EC1M 6BF
inquiries@duckworth-publishers.co.uk
www.ducknet.co.uk

Cataloging-in-Publication Data is available from the Library of Congress

Manufactured in China
US ISBN 978-1-59020-145-9
UK ISBN 978-0-7156-3870-5

10 9 8 7 6 5 4 3 2 1

Contents

A Mother's Gift, A Child's Homage

Introduction by Judith Thurman

THE ARTISTS' MOTHERS IN THIS VOLUME come from all walks of life—peasants, noble-women, intellectuals, a former slave, a governess, housewives, feminists, courtiers, artisans, enterprising business women, homebodies, and world travelers. They are plain and glamorous, old and young, pensive and confidant. Some had long, happy marriages and lives of ease, while a striking nmber were widowed or abandoned, and struggled to support their families. Arshile Gorky's mother starved herself to death during the Armenian genocide so that her children might survive. The patrician mother of Mary Cassatt, an impeccable matron, revelled in her unmarried daughter's bohemian freedom. If we are lucky, we live on in our children, and if we are wise, we try not to live through them, though perhaps more of the mothers than one knows nurtured their own thwarted, secret ambitions. Almost all of them were influential in shaping or supporting their child's career, and in many cases, the portrait they sat for is the best or most famous work that he or she ever produced (pious Mrs. Whistler is, for one, much better known—and better loved—than her flamboyant son), But whatever their story, these women all have something in common with each other—and with every mother who reads this book.

When my son was about two, he referred to himself, as most toddlers do, in the

third person—as "Will." Then, one day, he was standing on the steps of a little house in the country, while I was puttering in the garden, and he suddenly called out to me: "I am here, Mama, I am here." He had discovered that irreducible pronoun, and his emphatic smile of complicity told me that he understood how momentous the shift was.

Maternal love takes many forms, not all of them benign, but one of the most essential is to provide an experience of attunement. "I see you" is probably the simplest expression of it. The security that he is seen and heard enables a child, as time passes, both to connect with others—to read their feelings and intentions, a crucial survival skill—and to be become an individual who is real to himself. The eyes of a mother are the first mirror we encounter, and while no human mirror is without distortion, a good mother (or, as the great child psychologist, D. W. Winnicott, puts it, more humbly, and more reassuringly, "a good enough mother") is able to provide a true reflection.

Every artist, in that sense, is also a mother, because the role of art, whatever it represents, has always been to provide the children of Eve and Adam with a self-conscious reflection of their place in nature and history; of their thoughts, fears, and desires; their flaws and absurdity; but also of their power and beauty—an image, in short, of their uniqueness. "I am here," the artist says, implying, as my son did, "And you are there. You see me, and I see you. We are two autonomous subjects, and there's a distance between us—the distance one needs for perspective—but we're in this together." Perhaps, in that sense, too, every mother is an artist's mother, whether or not her child has an esthetic bent. A mother's gift is, ultimately, the example of steady, impartial discernment that each of us needs to create a self-portrait. And in whatever style they painted their mothers, the artists on these pages gratefully returned that deep gaze.

The Artist's Mother

The Artists
and Their
Mothers

Albrecht Dürer

(1471 – 1528)

Son of Barbara Holper Dürer

❦

WHEN HE WAS NINETEEN years old, Albrecht Dürer painted a double portrait of his parents. Albrecht was about to leave to become a journeyman and perfect his art, and this work, with its companion—a similarly sensitive portrait of Albrecht's father—are the earliest surviving paintings by a boy who would turn out to be one of the great masters of Western art.

Although Albrecht was young when he had his mother sit for him, this painting was a show of craft that outdid everything his predecessors in German painting had accomplished. His color scheme and content might appear in keeping with medieval painting techniques, but his careful attention to the detail of his mother's face was a rupture with what had come before him. With his first surviving paintings, Albrecht was already fomenting a revolution, one that would see him immortalized as the great painter of the Northern Renaissance, an icon even in his own time.

The subject of this particular early painting was obviously dear to his heart. Barbara would only have been thirty-nine or forty years old when she sat in the family's home in Nuremburg, but her life up to that point had not been an easy one. Although Albrecht was one of only four of her offspring to survive childhood, she gave birth at least eighteen times. She had been married to her father's assistant, a lonely Hungarian from a line of goldsmiths, when she was fifteen years old. Her husband—Albrecht the Elder—was at least twenty-five years her senior, and she was widowed only a decade after this portrait was painted. Despite the sorrow of losing child after child, Barbara was a key supporting figure in young Albrecht's career. She was the closest person to him for much of his life, particularly after the death of Albrecht's father; Albrecht chose to spend the glory years of his rise to fame with his widowed mother.

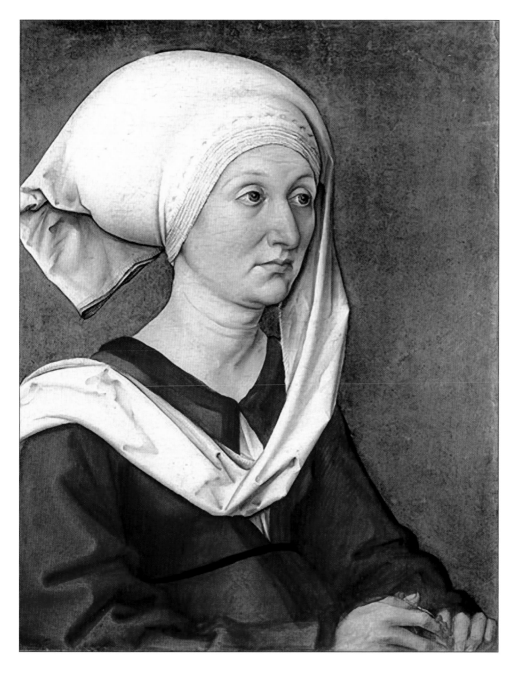

Albrecht's portrait of his mother, Barbara, painted in 1790.

Perhaps more famous than the early oil painting of Barbara is this charcoal drawing, which Albrecht executed at the peak of his career and only two months before his ailing mother's death. Contrary to medieval artistic sensibilities, which insisted that unflattering or ugly depictions were a symbol of sin, Albrecht chose not to idealize his mother or smooth away her wrinkles. Instead, he instilled reverence into the graceful references to age and hardship he let show on her face.

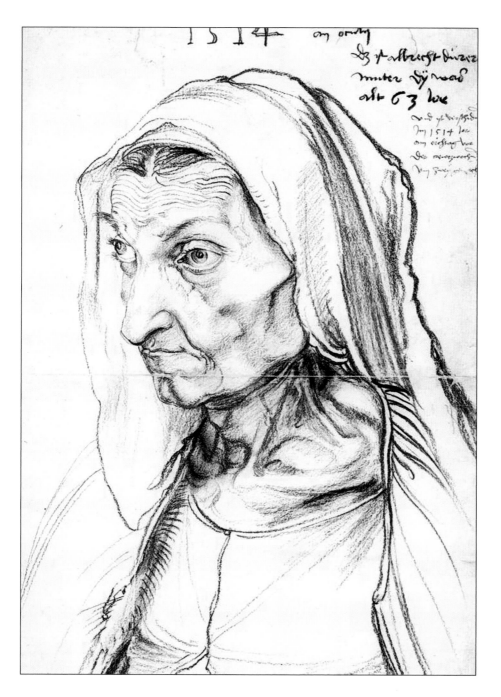

Portrait of the Artist's Mother, a charcoal drawing of
Barbara Holper Dürer completed in 1514.

Guido Reni

(1575 – 1641)

Son of Ginevra de' Pozzi

🌿

GUIDO RENI WAS A LEADING MASTER of Baroque painting, his generation's royal favorite. Pope Paul V was among his patrons. Like great artists of every generation, he became known among his pupils, and among enthusiasts, for the complexity of his psychology and the many unusual aspects of human nature that he captured. Among his own eccentricities were an obsession with hygiene and a fear of women—no females were allowed into his house, and even his servants had to be male. Guido Reni was an avowed virgin, and he became deeply flustered by a casual reference to reproduction or, God forbid, a dirty joke.

Only Reni's mother escaped his misogyny. He was wholly devoted to her. His worshipful love comes through in this subtle and respectful portrait. It also comes through in the rest of his oeuvre, which is replete with lush, warm, and exalted depictions of the Madonna.

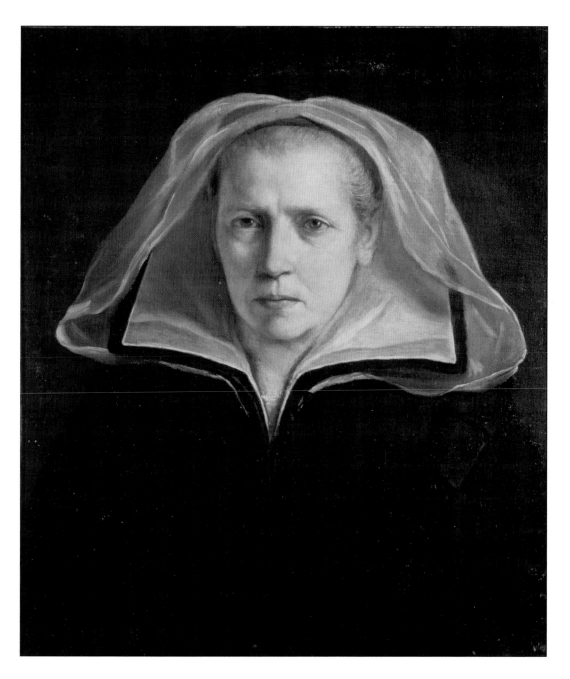

Guido Reni's portrait of his mother.

Sofonisba Anguissola

(1532 – 1625)

Daughter of Bianca Ponzone

❧

WHEN SOFONISBA IMAGINED HER MOTHER in this rich golden dress, she recreated a picture of beauty and sophistication that couldn't have come from her own memories. Sofonisba gave Bianca a full, ornately embroidered skirt, dazzling giant pearls at her throat and in her hair, and a youthful face, glossed with light. She turned mother's mouth up at the corners, and gave her eyes a direct, almost confrontational gaze. Bianca was, at least in Sofonisba's mind, a strong woman of great poise and noble carriage.

Bianca, however, died when Sofonisba was only four or five. This vividly imagined picture expresses an idealized memory and an acute, poignant sense of loss. It was executed when Sofonisba was twenty-five, already well on her road to a successful career of commissioned portraits, and nearly on her way to fame in the royal courts of Spain, to which she would emigrate from her native Lombardy two years later.

Bianca's noble breeding and feistiness were traits that were inherited by her six daughters. During a period when women were barred from almost all careers except, perhaps, as abbesses or, at the other extreme, as courtesans, and were thwarted at every turn when they tried to excel, Bianca and her husband, Amilcare, decided to encourage their daughters to pursue their interests and talents aggressively. The girls were all educated from an early age, and in this enlightened environment, they flourished. Four would become painters; a fifth became a scholar of Latin.

Sofonisba, the most gifted of the brood, contributed more to art than her paintings. With her high profile and international acclaim, she opened the door for other young women who wanted to become artists. Sofonisba was a master portraitist who earned prizes, high wages, a position at the Spanish court, and a marriage sponsored and blessed by the Spanish king, Philip II, who supplied her with a dowry. But her best portraits are often the ones that she made for herself, with the intimacy and personal attention she so lovingly paid to Bianca here.

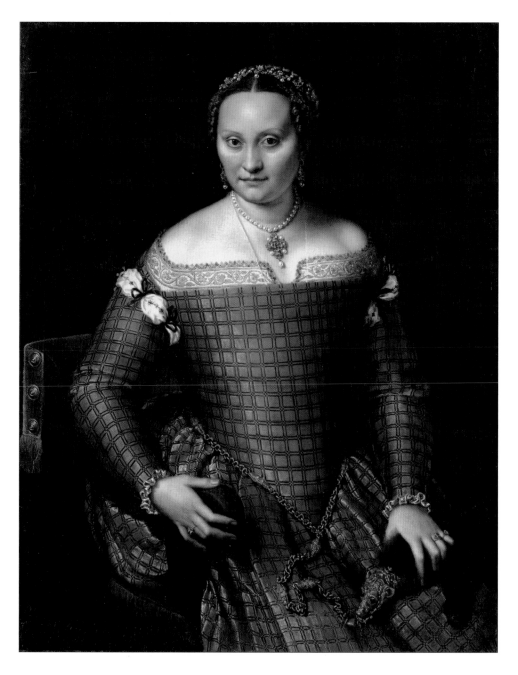

A richly imagined portrait of Bianca Ponzone by her daughter, Sofonisba Anguissola, painted around 1557.

Rembrandt Harmenszoon van Rijn

(1606 – 1669)

Son of Neeltgen (Cornelia) Willemsdochter van Zuytbrouck

❧

A
T FIRST BLUSH, THE WOMAN depicted in this painting looks fairly humble and unassuming. She is clearly aged, her back is hunched, and her face and hands wrinkled. Perhaps if the word "Prophetess" in the title hadn't caught our attention, we would write her off as a decrepit old lady.

But a second look makes the viewer pause. The pose of the Prophetess Hannah is hardly unselfconscious. She holds her book raised to her face, her right hand actively scanning the text, in a moment of concentration and excitement. Rembrandt managed to imbue the portrait with mythic energy.

The mastery of the painter, however, is to some degree dependent on the expressiveness of his model, and the Prophetess Hannah was clearly such a sitter. Her face is sharp and still and her expression is realistic. So not only did Cornelia, Rembrandt's mother, play along with her son's scenario, not only did she agree to sit for him for hour after long hour, not only did she submit to the costume and the pose, she relished it. And her pleasure is clear not only from her convincing acting job in this picture, but also from the fact that she sat for painting after painting—for Rembrandt, as well as for many of his pupils. In this portrait, Cornelia was sixty years old, a pious woman who had worked hard for decades to take care of her family, and had now found a higher calling: as a muse for great art.

The series of portraits that Cornelia sat for were painted in the late 1620s and early 1630s, starting around the time that Rembrandt was in his early twenties. Cornelia and

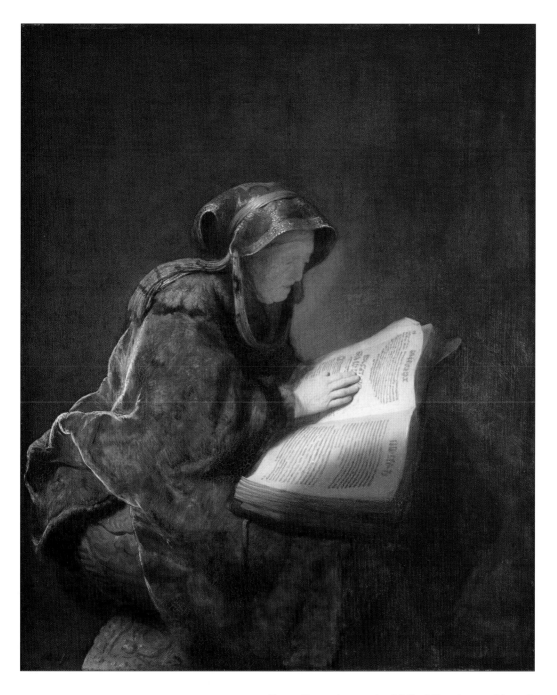

Cornelia posing as the biblical Prophetess Hannah
in an oil painting completed in 1631.

her husband, Harmen, had allowed Rembrandt to move back into their Leiden house after his apprenticeship so that he could work on launching his career. With a studio under his dear mother's roof, Rembrandt was eager to have her pose for him. His early work, dating from around the time he was twenty-two, includes a series of sketches, studies, and full oil portraits of Cornelia. Sometimes she is reading, sometimes praying, sometimes posing in a biblical costume; sometimes, she simply sits. What all the pictures have in common is their great tenderness. The reverence with which Cornelia gazes at her Bible echoes the reverence with which the painter, her son, labored over the curves, shadows, and rich details of her wrinkled face.

A vainer mother might have been upset if her son or daughter took such care to accentuate the signs of her age. But Cornelia sat again and again for her son, in part, perhaps, because there was a great fad at Rembrandt's time for painting "old age" and for offering respect to a subject by dramatizing his or her wisdom lines—and Cornelia's wonderfully textured face inspires a feeling of familiarity, honesty, and kindness. Rembrandt owed some of his early acclaim to his ability to depict old age with deep feeling.

Cornelia had certainly earned her iconic wrinkles. Rembrandt was the eighth of nine children, and hadn't exactly been an angel growing up. Both Cornelia and Harmen were from prosperous, decidedly middle-class families—she was the daughter of a baker and he was a miller—and they had hoped their children would be able to take advantage of their parents' hard work and distinguish themselves. They cobbled together enough money so that Rembrandt did not need to take an apprenticeship in either his mother's or father's family businesses—they

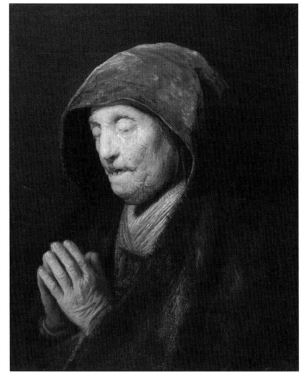

Rembrandt called this portrait of his mother *An Old Woman at Prayer,* painted in 1629–30

The Artist's Mother

were able to send him to the Leiden Academy for a degree in law or theology. He was the first child they destined for schooling and they had high hopes for him.

Alas, academia was not the right place for Rembrandt. He did not care about law or theology. As his first biographer, Jan Jansz Orlers, wrote in 1641, Rembrandt "had no desire or inclination whatsoever in this direction because by nature he was moving toward the art of painting and drawing." Orlers, with hindsight, could afford to be philosophical about Rembrandt's failure to excel at the academy, but Cornelia and Herman must have been at least a little distressed. It was, however, a time of prosperity in the Netherlands—a lull between wars. His parents accepted his ambitions to be a visual artist and

Here, Cornelia posed in another biblical costume for Rembrandt's friend Gerrit Dou; *Old Woman Reading a Lectionary*, 1630.

managed to apprentice him to a local master who had lived in Italy for twenty-five years. Thus when he was only fourteen, Rembrandt began his education as a painter.

Cornelia was a financial and emotional rock for Rembrandt. Not only did she encourage him, she housed and fed him and gave hours of her time to posing for him and his friends. This version of the Prophetess Hannah was done by Gerrit Dou, another Dutch master several years Rembrandt's junior. Again, Cornelia took an active pose, engrossing herself in her reading.

Rembrandt is one of many painters famous for his colorful liaisons. During a fairly long life enlivened by interesting affairs (notably among them an affair with his son's nanny, and another with his housekeeper) Rembrandt affectionately painted a number of women. But his mother was first among them.

Hyacinthe Rigaud

(1659 – 1743)

Son of Maria Serra Rigaud

Hyacinthe Rigaud was born Jacint Rigau I Ros in the Catalonian village of Perpignan, but he made his name in the royal court of France. He was best known during his lifetime as a portraitist, particularly as the portraitist of King Louis XIV, whom he painted again and again. Those paintings have been reproduced for centuries in books about the Sun King. The subject wears gorgeous robes, furs, and voluminous wigs, and he is nearly always posed with his left leg extended, ballerina-like, in front of him, so as to show off his physique to the greatest advantage.

Despite his royal clientele, the Hyacinthe Rigaud portrait that contemporary critics consider to be his best is this portrait of his mother, of 1695. The unorthodox composition—Maria Serra faces herself—is eye-catching and curious, and the subject's character is more important than any gaudy accoutrements. The painting was executed over the summer, when Hyacinthe returned to his Catalan hometown to visit his family. At that point, he was already extraordinarily famous, having won the Royal Academy's Prix de Rome, and having been chosen as an official portraitist by the royal family. Although the painting was exhibited at the Salon of 1704, Hyacinthe painted his mother for himself—he kept the portrait in his private collection and treasured it all his entire life.

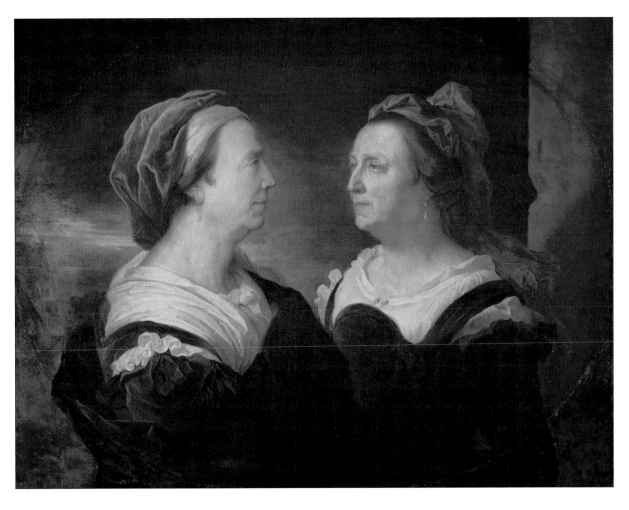

Madame Rigaud, Mother of the Artist in Two Positions,
or *Portrait of the Artist's Mother,* 1695.

The Artist's Mother

Elisabeth-Louise Vigée-Lebrun

(1775 – 1842)

Mother of Julie

❦

ELISABETH VIGÉE-LEBRUN, like her predecessor Hyacinthe Rigaud, made her name as a royal portraitist. She was the favorite of Marie Antoinette, who posed for Elisabeth many times. The artist's paintings of the Queen and her children decorated the walls of Versailles both before and after the French Revolution. She would be admitted to the academies of Rome, Switzerland, and St. Petersburg, and would become the portraitist of Catherine the Great and her family. Yet half a century after her death, art critic Edmund von Mach would refer to her in his catalog of great nineteenth century painters as "best known for the pictures of herself and her daughter."

Elisabeth Vigée-Lebrun had two great loves in life: painting, and her daughter, Julie. Although the joy of motherhood was an unexpected surprise for her—she had been married against her wishes at twenty to a degenerate art dealer who brought her nothing but annoyance and strife—painting was a true calling. Elisabeth had circumstance on her side. She was born in Paris into a family consumed by art. Her father was a leading portraitist himself, and her mother, who was committed to Elisabeth's education, spent each Sunday with her at the Tuileries and the Luxembourg Palace, studying the masterpieces in the galleries. Elisabeth was also extremely precocious. Her father died penniless when she was twelve, but the family was able to survive until her mother's remarriage because Elisabeth was already earning handsome wages from commissioned portraits, despite her extreme youth. She was admitted to the Academy when she was nineteen, a year before her unfortunate marriage to Jean-Baptiste-Pierre Lebrun, a pleasant man who turned out to be an incurable gambler. In her memoirs, Elisabeth wrote that he managed to lose more than one million francs of her money by the time she fled France during the Terror of 1789.

Elisabeth Vigée-Lebrun painted herself many times with her daughter, Julie. This, perhaps her most famous depiction, was called *Self-Portrait with Daughter* and was completed in 1789.

This unhappy marriage was, however, what produced Julie, the greatest happiness of the artist's life. Elisabeth enjoyed her renown in the art world, but wrote: "These pleasures of gratified vanity were far from comparable with the joy I experienced in looking forward to motherhood. I will not attempt to describe the transports I felt when I heard the first cry of my child. Every mother knows what those feelings are." Elisabeth and Julie were inseparable. Upon their escape from France in 1789, Elisabeth and her daughter, who was only five at the start of the Revolution, were alone on an adventure that took them across Europe. In her memoir, Elisabeth reminisced about walking to the seashore in Italy together and staying until moonrise. Her portraits supported them, and she focused for the rest of her life on making sure that Julie had the best education possible. Elisabeth arranged tutors for writing, geography, Italian, English, and German, and nurtured her daughter's love of writing novels.

"She was charming in every respect," Elisabeth wrote of her daughter. "Her large blue eyes, sparkling with spirit, her slightly tip-tilted nose, her pretty mouth, magnificent teeth, a dazzling fresh complexion – all went to make up one of the sweetest faces to be seen… A natural dignity reigned in all her person, although she had as much vivacity of manner as of mind." The enraptured mother went on to list her daughter's flawless memory, excellent music abilities, and perfect disposition for being painted. "When my friends said, 'You love your daughter so madly that it is you who obey her,' I would reply, 'Do you not see that she is loved by every one?'

Elisabeth Vigée-Lebrun's oeuvre includes almost nine hundred paintings and more than six hundred portraits. But despite her royal clientele, her best-remembered paintings are the ones she loved best herself, the paintings of her daughter.

The Artist's Mother

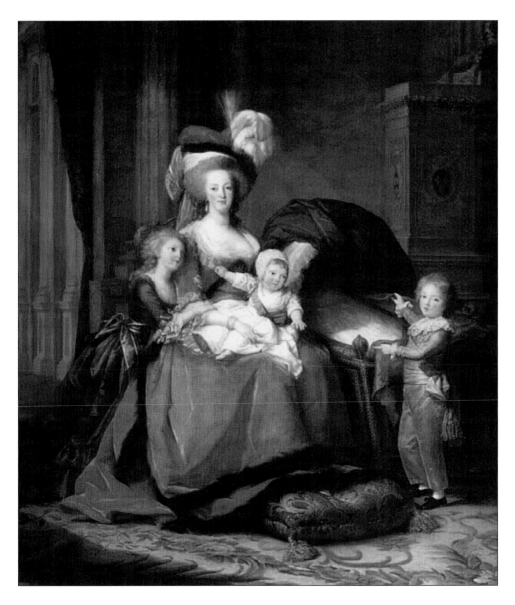

One of Elisabeth Vigée-Lebrun's many portraits of Queen Marie Antoinette, depicted here with her children in 1787.

John Constable

(1776 – 1837)

Son of Ann Watts Constable

❧

JOHN CONSTABLE, WHO WOULD BECOME one of England's greatest landscape painters, was the favorite of his mother's six children. For two thirds of his life, Ann Constable cooked for her son, sent him clothing when he was away studying art, and cajoled her husband, Golding, into giving her money, which she slipped to John. In a motherly fashion, she worried about him constantly, particularly when he was at school. "Pray be very Careful of yourself," she wrote to him in London. "I form an idea that the warmth of the Academy Room – smoke from Lamps or many Candles – & then Coming into the air & Streets of London are most inimical to tender Chests & Lungs – therefore do not be too adventurous – not sit up *too late*." Sound familiar?

John and Ann looked after each other—their complicity was deep. John's portrait of Ann was painted some time between 1800 and 1815. In it, however, she appears as she might have in the 1770s or 1780s. John flattered his mother by taking several decades off her face. Ann was constantly urging John to be more productive and less self-critical—she urged him not give up on works because they didn't meet his standards of perfection. She herself was always thrilled by her son's work. In one of her many letters, she calls him "one bright genius & one Pair of hands."

This portrait, entitled simply *Ann Constable*, was painted some time around the turn of the 19th century.

Jean Baptiste Camille Corot

(1796 – 1875)

Daughter of Marie-Françoise Oberson Corot

❧

ALTHOUGH HER SON THE PAINTER never felt any pressure to make a career for himself, nor even to leave the house very often, the same can not be said of Marie-Françoise Oberson Corot. She was twenty-four years old when she married Louis-Jacques Corot, who was only twenty-one, and she came into her marriage with a sizable inventory of properties—family holdings in Switzerland and Versailles—as well as cash. One of the first things she did after getting married in 1793 was to take a lump of that cash and buy a hat shop in Paris.

Louis-Jacques, an enterprising young man with a head for business himself, had inherited his father's wig shop, and for a while the couple thrived on the profits from their respective headgear. By 1798, however, Louis-Jacques saw that his wife's enterprise was going to be the more successful, and he gave up his own shop to support Marie-Françoise. She, in the meantime, was becoming quite famous as a milliner of great artistic talent. One of their son's biographers, Étienne Moreau-Nélaton, wrote in 1924 that "Mme. Corot rivaled in taste and stylish inventiveness the famous Mme Herbault, who made hats for [the Empress] Josephine and her attendants." In 1801 the Corots opened a second shop across from the Pont Royal. Business was booming.

Into this harmonious bustle of art and industry Jean-Baptiste-Camille was born in 1796. He lived with his parents and two sisters in an apartment above the original hat shop on the rue du Bac. Camille, who grew into a tall, solidly-built boy, worshipped his mother and, Moreau-Nélaton wrote, "trembled when his father spoke." That was a classic model of the 18th-century family dynamic: a stern father and a loving, attentive mother. In the Corot household, however, Marie-Françoise was the main provider.

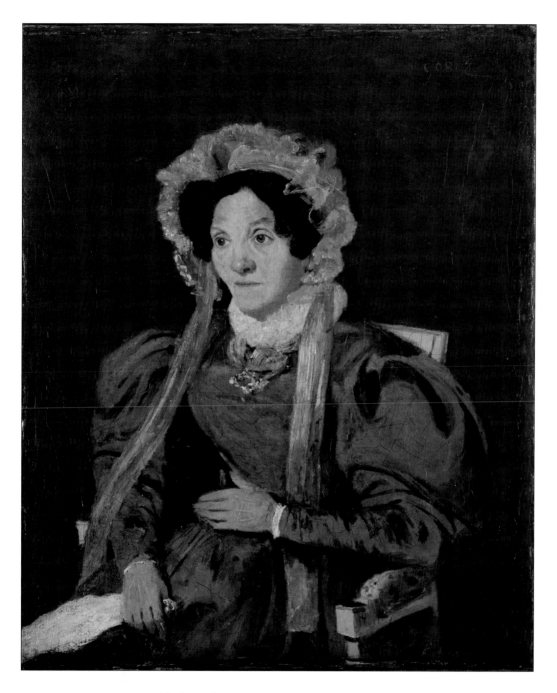

Madame Corot, the artist's mother was painted between 1833 and 1835.

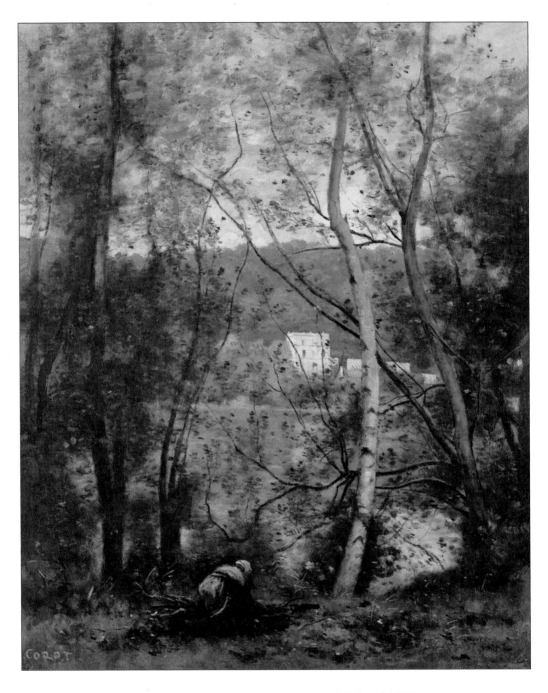

A Woman Gathering Faggots at Ville-d'Avray, painted between 1871 and 1874,
is one of several pieces Corot painted that were directly inspired
by the view from his window in his parents' new house.

Marie-Françoise was a forerunner of the modern working mother. She went straight back to work after giving birth to each of her children. During business hours a nurse cared for the Corot kids until they were old enough to go to school. This did nothing but make the family more of a tight-knit, functional unit, all very close to one another. Camille spent many hours in his mother's shop, although he was very awkward around his mother's female clients.

Camille was very happy in the bosom of his family, particularly in the company of his mother. After a stint at boarding school (where he did not especially distinguish himself) he returned to Paris, where, in 1817, his parents purchased a house. The garden was very picturesque, and the property adjoined two ponds once owned by Marie-Antoinette. Camille, who was twenty-one, promptly installed himself in a small bedroom on the third floor of the house. He was twenty-one, and would occupy these quarters until his death.

For the next thirty years, Marie-Françoise was the person closest to Camille. She paid for his transformative trips to Italy; she was his constant companion and dinner date. Even into his fifties, Camille would ask her permission before dining out on a Friday evening.

Christen Købke

(1810 – 1848)

Son of Cecilie Margrete Købke

C HRISTEN KØBKE WAS BORN IN COPENHAGEN in 1810, the fifth of eleven children. Nineteen years later, he painted this exquisitely subtle portrait of his mother. Like many of Christen's paintings, the portrait is small, about ten by eight inches. He would go on to become one of the great painters of the Danish Golden Age, building his career on similarly modest but wonderfully observed studies, often of domestic scenes, buildings, and landscapes. He had taken up painting at eleven, when he was confined to bed with a bad fever. A year later, he entered the Royal Danish Academy of Art and launched a career that would be short but brilliant.

Although Cecilie clearly dressed up for the portrait in her Sunday best—a blue silk dress and lace bonnet—she doesn't look overjoyed to be posing. Nevertheless, the viewer can read into her gaze what one art critic called "a conspiracy of silent affection" between mother and son. However grudgingly she sat, Cecilie held her pose with patient resignation—a quality of mothers everywhere, and throughout this book.

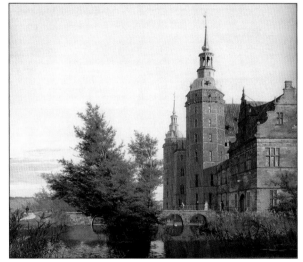

Frederiksborg Castle Seen from the Northwest, 1836, is another example of Købke's virtuosity.

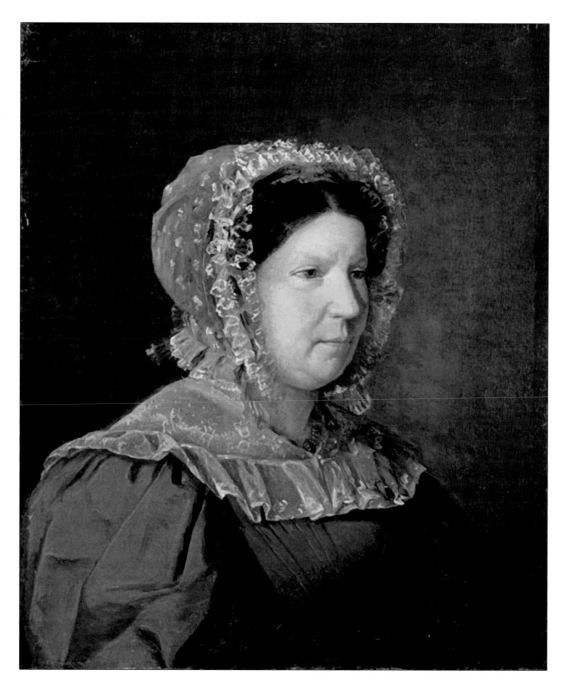

Portrait of Cecilia Margrete Købke, the Artist's Mother, 1829.

Dante Gabriel Rossetti

(1828 – 1882)

Son of Frances Mary Lavinia Polidori

FRANCES POLIDORI WAS THE ONLY MEMBER of her household who never published a book. She was the wife of a prolific scholar of Italian poetry and the mother of four precociously artistic children, but she had never been an underachiever. "I always had a passion for intellect, and my wish [was] that my husband should be distinguished for intellect, and my children too," she wrote. "I have had my wish—and now I wish that there were a little less intellect in the family so as to allow for a little more common sense!"

As much as she might lovingly mock her high-brow family, Frances was, in part, responsible for their achievements and drive. She was well-connected (her brother was Lord Byron's physician) and well-cultivated. Her own classical education inspired a deep conviction about free expression. The classroom she set up for her children in her London parlor became a nurturing matrix not only for the Rossettis, but for the entire pre-Raphaelite movement. The pre-Raphaelite Brotherhood, a school of poets and painters that is considered the first avant-garde movement in modern art, was founded in 1848 by a small group led by Frances's two sons, Dante and William Rossetti. The Brotherhood sought to divorce itself from Victorian rigidity, and what its members considered to be the overly formulaic rules of contemporary academic painting. Pre-Raphaelite painting is notable for its embrace of colorful historical pageantry and the fleshy female form of the Italian Renaissance—the rejection of the corset, for example. Dante, the Brotherhood's visionary forerunner, celebrated joyful biblical vignettes (like this one of Saint Anne tutoring the Virgin Mary), illustrations from *The Inferno* and the Arthurian sagas, and suggestive scenes from decadent bedchambers of ladies swathed in silk. Pre-Raphaelite masterpieces are vivid and lush, suggesting an unabashedly erotic relationship with the act of viewing.

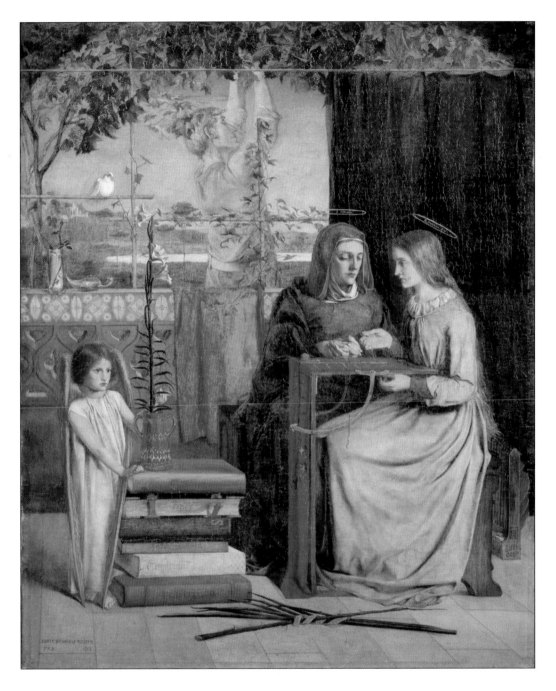

In this painting, *The Girlhood of Mary Virgin*, which he painted in 1849,
Dante depicted his mother, Frances, as St. Anne.

The Artist's Mother 39

The Rossetti children were practically more Italian than English (not withstanding the fact that Frances trundled them to Anglican church every Sunday). She herself was half Italian, one of eight children of a Tuscan expatriate living in Paris who took refuge from the Terror at the end of the French Revolution. In her youth, Frances worked as a governess. At twenty-five, she married a man in her father's mold—an Italian expatriate poet and scholar, Gabriele Rossetti, who was eighteen years her senior. She gave up her job to use the same didactic talents in raising four of Victorian England's great intellects: Maria Francesca, the critic; William Michael, the editor and reviewer; Christina, the poet; and the painter, Dante Gabriel, the most famous of them all.

Thanks to their mother's vigilance, all four Rossetti children were well-rounded in many arts—Renaissance children, you might say. It was Frances's dedication that kept them from having to take up more prosaic jobs. Although their childhood was a time of relative prosperity, the situation changed when Gabriele became ill and unable to work. Much of the responsibility for the family's survival then fell to Frances. During the 1840s, Dante, a teenager, was already enrolled in a prestigious art school, and Frances refused to consider taking him out. She went back to work as a governess, employed by the family of a banker.

The Rossettis were forced to move to a smaller house in 1850, and Frances began to take in pupils. Christina was the assistant teacher, and together they struggled to earn enough money to maintain a middle class way of life. But Frances continued to indulge her favorite son, slipping Dante money to underwrite a bohemian lifestyle even as he refused to exhibit his work. She was convinced that his talent was worth whatever hardships went to subsidize it. William, on the other hand, was less indulgent. "There was our father incapacitated," he wrote, "our mother and Christina fagging over an unremunerative attempt at day-school; Maria giving lessons in Italian etc., at two or three houses; myself with a small salary." When Dante achieved glory, Frances saved all of his reviews.

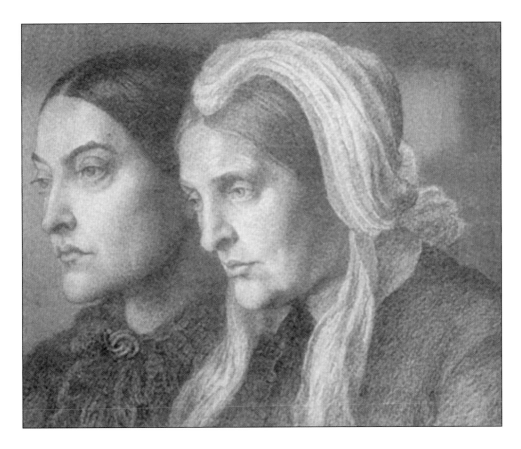

A sketch Dante made of his mother, Frances, and his sister Christina.

Paul Cézanne

(1839 – 1906)

Son of Anne Elizabeth Honorine Aubert Cézanne

❧

ACCORDING TO MARIE CÉZANNE, the artist's sister, her brother Paul "loved her [their mother] dearly." Marie, who joins her mother in this painting, went on to say that young Paul "was no doubt less afraid of her than of our father, who was not a tyrant but was unable to understand anyone except persons who worked in order to get rich."

Elizabeth, as she was known, was a free spirit and the source of compassion and warmth in the Cézanne house. She was a provincial girl born in Aix-en-Provence, a city immortalized by her son. Elizabeth had been charmed off her feet by Louis-Auguste Cézanne, who had arrived in Aix to become a haberdasher. She was twenty-four when they met, he almost forty, but he talked her into living in sin. Elizabeth and Louis-Auguste didn't bother to get married until Paul was five years old, and Marie two.

Although Elizabeth wasn't educated, she was extremely imaginative and interested in the arts. Marie wrote that her mother would regularly remind Paul, who showed an early aptitude for the visual arts, of the other great painters who had been named "Paul" throughout history. She was certain that it was his destiny to become a great painter.

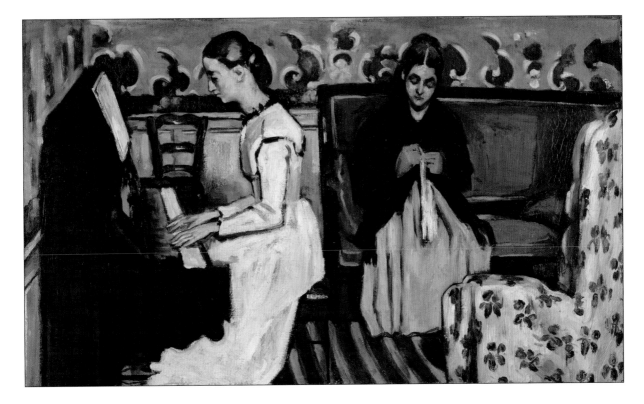

Girl at the Piano (Overture to Tannhäuser), or *Portrait of the Artist's Sister and Mother,* was painted in 1868–9.

Berthe Morisot

(1841 – 1895)

Daughter of Marie-Joséphine-Cornélie Thomas Morisot

✿

BERTHE MORISOT'S PORTRAIT OF HER MOTHER and sister looks uncontroversial. Her graying mother is reading to her pregnant sister in a charming domestic scene. The color palette is muted and calming, and the painting was a great success at the Salon of 1870. No one would guess what a storm it caused in Berthe's life.

Berthe's mother, Cornélie, was present as Berthe was finishing the canvas—her entry to the Salon. She asked her colleague Pierre Puvis de Chavannes for advice, and he told her there was something wrong with her mother's head. He didn't have time to help her fix it, he said, since he was busy with his own entry. Doubting herself at the last minute, Berthe called her friend Édouard Manet to reassure her. Manet was arguably the leading painter of his day, and the brother of Berthe's future husband, Eugene. When he appeared at her studio, Manet told her not to worry about the head—the painting was very good, he said. But, uninvited, he began to touch it up, adding a few brushstrokes to the dress.

"That was where my misfortunes began," Berthe wrote to her sister, Edma. "Once he had started nothing could stop him; from the skirt he went to the bodice, from the bodice to the head." Berthe was too bashful to stop Manet, but she was mortified that another painter was changing her composition. She told Edma that Manet "cracked a thousand jokes" and "laughed like a madman" as he applied paint to the canvas that she had worked so hard on; he was quite confident that his "help" would improve it. But his mocking laughter made a farce of her serious ambition.

At that moment, Berthe had a revelation. She needed to distance herself from Manet. Their friendship, and her gender, had somehow given him the idea that he had a right to alter her painting without permission. She was not his student, and he was not her teacher;

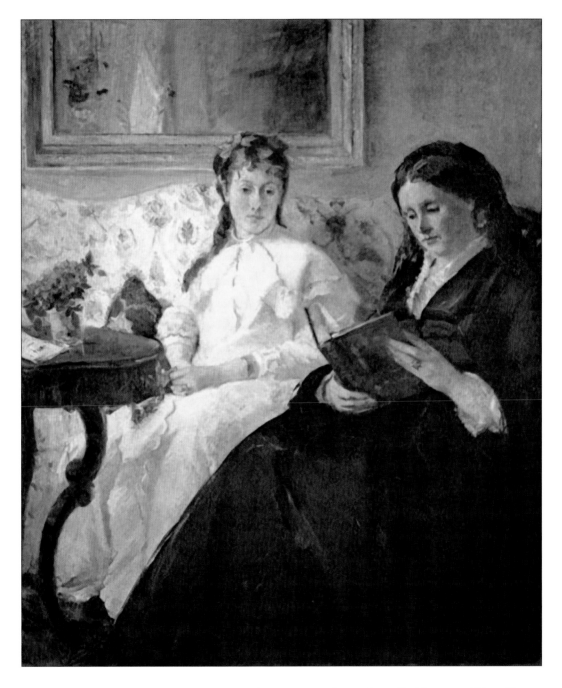

The Artist's Mother and Sister, also called *Portrait of Mme Morisot
and Her Daughter, Mme Pontillon*, 1869–70.

it was an outrageous presumption on his part. If she was going to be a professional, she had to assert her equality with, and her right to respect from, the men in her circle. If Berthe was furious with Manet, she was even angrier with herself for standing meekly by while he meddled with her creation. It was too late, though—a cart was waiting at her door to transport the canvas to the Salon.

Cornélie, who had done her best to keep peace in the studio and to flatter both parties, watched the whole saga unfold with great distress. She wrote to Edma that Berthe "kept telling me that she would rather be at the bottom of a river than learn that her picture had been accepted" at the Salon. Cornélie did her best to calm her daughter and eventually convinced her not to withdraw the painting; withdrawal would be an open affront to the powerful Manet. Berthe swallowed her pride, and maintained her relationship with Manet and his family. Four years later she would marry Eugene. The continued professional association between Berthe Morisot and Édouard Manet would alter both of their careers and jump-start the Impressionist movement. Although Édouard is credited with introducing many key Impressionist concepts, it was Berthe who first persuaded him to paint in *plein air*, and it was Berthe who introduced Édouard to the circle of painters who would eventually become the Impressionists.

Cornélie Morisot, the calm model in the contentious portrait, wanted the world for her daughters. She was a progressive mother who believed in affection, not harsh discipline. A pretty and refined woman of the world and the belle of Bourges, where her family lived, Cornélie raised her daughters to move easily in high society. Berthe would remember her mother as having been "the picture of youth and happiness" as a younger woman. Cornélie loved music and was an accomplished singer and pianist. Her daughters inherited their mother's passion, and Berthe often painted children practicing a musical instrument.

The Morisot house was an enlightened one. A model wife and mother herself, Cornélie made sure that her daughters did not feel that marriage and maternity were the only routes to happiness for a woman. Most important, she wanted them to be educated. Instead of enrolling Berthe and her sister Edma in a traditional finishing school, Cornélie found the girls a private Parisian day school called Cours Adeline Désir. The rigorous curriculum included drawing and painting. At the time, however, even serious female art students were only taught watercolors and pastels. In the 1850s and 1860s, oil painting was for men only; the paints were thought to be bad for a woman's health, and the technique beyond their ca-

The Artist's Mother

pabilities. Berthe, however, was determined to paint with oils, and her parents paid for private lessons with Camille Corot, the most famous Parisian master of their day.

Cornélie was a tireless champion of her daughters' work (Edma was a painter, too). In 1875, she told Berthe proudly that one of her paintings was on sale in a local shop for six hundred francs. Unlike her contemporary Mary Cassatt, Berthe did not feel obliged to sacrifice her life as a woman for her life as an artist. The years that followed her marriage, at thirty-two, to Eugene Manet were her most prolific. Berthe became the "First Lady of Impressionism" on the strength of her talent, but also because of Cornélie's unflagging support.

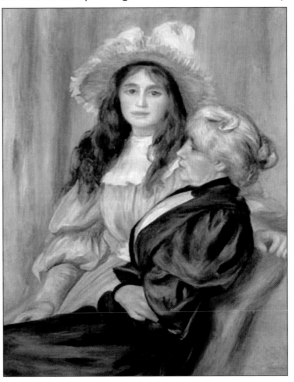

Pierre-Auguste Renoir painted this picture of his friend Berthe Morisot and her daughter, Julie Manet, in 1894. As an homage to the subject, the painting mimics the 1870 portrait Berthe painted of her mother, Cornélie, and her sister, Edma.

James Abbott MacNeill Whistler

(1834 – 1903)

Son of Anna MacNeill Whistler

❧

EVEN IF YOU DON'T KNOW anything about her, you can't help but recognize her in passing. Anna MacNeill Whistler is one of the best known mothers in the world. You might not know her given name, but you've probably seen her face on a Mother's Day card, on a postage stamp, or a sampler hanging in someone's living room. And yet, her likeness has not ceased to be moving. There is something about her face—something of forbearance and grace—that reminds us of our own mothers, or of the maternal ideal.

It is unlikely that James Abbott McNeill Whistler could have predicted that his own career as painter would be eclipsed by his mother's career as subject. *Arrangement in Grey and Black* (the official title of the painting) would be his most famous work. We respond to "The Mother," as it immediately became known, not quite as much because of the beautiful color balance or the play of light but because of Anna, and the universal Mother that James captured in her expression and posture.

Luke Ionides, an in-law, later remembered that "Whistler's mother was a most delightful old lady, who always treated him as if he were a little boy, and used to scold and reprove him… She was very tactful and very pious." Anna was born 1804 to Scottish Americans, and married George Washington Whistler, a family friend, in 1831. She spent the rest of her life in a household of men. George already had three children (two boys and a girl) from his late first wife; Anna bore him five more children, all boys, although three died before age five. She loved George deeply, and wrote to James about her husband's death: "Oh Jemie this home is so desolate without him! I mourn my loss so deeply!" Ever the exemplary Protestant wife and mother, Anna wrote that she looked to God and prayer to comfort and sustain her so she wouldn't "sink under the weight

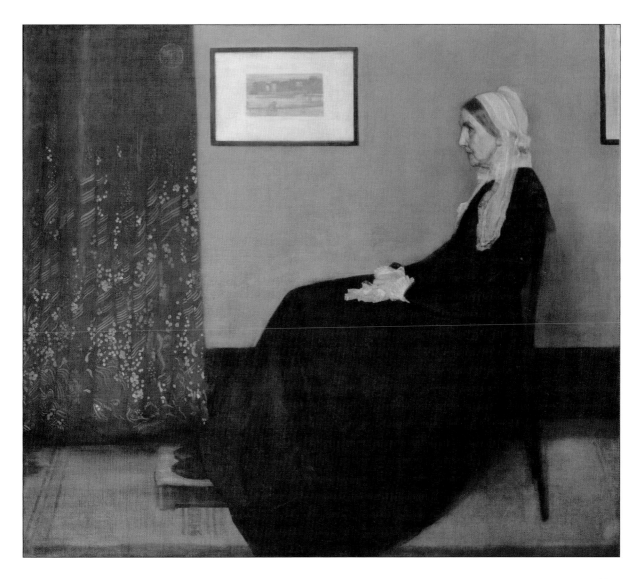

Arrangement in Grey and Black, or "The Mother," as it has come to be known, 1871.

of my selfish sorrow." Anna was seen by her contemporaries as the poster child for Protestant virtue and Victorian propriety.

James and Anna were close and affectionate. In 1867, he wrote to his mother: "you my Mother of whose continued kind indulgence and patient forgiveness and loving cheerfulness I have so many proofs!... I am so pleased Mother dear with the affectionate interest you take in my pictures." When James painted "The Mother," he and Anna had been living together for eight years in his house in London. Anna had moved to England to join her son during the American Civil War. While she had sympathized with the North, her son sympathized with the South. They had to relearn to live together on more worldly terms. Anna stopped visiting James' studio unannounced when she walked in on a session with the parlor maid, who was "posing for the all over," as Anna put it.

The Whistlers were a cosmopolitan American family. James had been born in Massachusetts but spent several years of his childhood in Russia, where his father was employed as a civil engineer on the new railroad. It was in Russia that Anna took control of her son's art career. A painting by the young James caught the attention of Sir William Allen, a famous Scottish artist, and Anna used this work as a calling card to get her son a place at the Imperial Academy of Fine Arts in St. Petersburg. When James was expelled from West Point, it was Anna who found him a geological surveying job in Washington DC. It was also Anna who negotiated James's first commission.

A series of myths have risen up around the creation of "The Mother." Some critics believe that James Whistler intended to make a standing portrait, but that his mother became fatigued. Others claim that Anna was a last minute stand-in for a model who never showed up. But Anna later was very proud of having made herself available to James for three months of posing. She wrote, "I refused all invitations to visiting relations here or friends." James worked slowly, and three months of posing was not abnormal for him, though an elderly lady could not be blamed for wanting a chair.

Ironically, "The Mother" was not well received by James' contemporaries. He submitted the painting to the Exhibition of the Royal Academy of Art in London in 1872, and it was the last painting he would ever submit to the academicians, who initially wanted to reject it. "The Mother" was James Whistler's rupture with the British art establishment. Although his break turned out to be a positive development for him, he was confused and frustrated by some of the criticism that he received. Viewers seemed entirely focused on the content

instead of the artistry; it was as if all his careful technique was invisible. Instead, critics wrote about "the dignified feeling of old ladyhood" and "a grave poetry of mourning—an effacement, depression, forlornness, with a strange and sweet dignity" that they saw in Anna's face. Everyone wanted to know about the impersonal title. When the sitter was his mother, why had he called it *Arrangement in Grey and Black?* "Now that is what it is," he insisted. "To me it is interesting as a picture of my mother; but what can and ought the public to care about the identity of the portrait?"

Regardless of the criticism, "The Mother" became a cultural icon almost immediately. It was reproduced in a magazine only a year after its debut; caricatures and wood engravings of it began to circulate. The British government used Anna's profile on a 1917 poster advertising war bonds with the slogan "Old Age Must Come," and in 1934 the United States Government issued a stamp with Anna's likeness. There was some controversy over that stamp, since a bureaucrat thought it was a good idea to hide Anna's feet with a flowerpot. The postal service was forced to amend its corruption of the original work, which was by now so famous that fans objected. FDR's mother, among others, posed for pictures in front of Mrs. Whistler. In 1938, the Mother's Memorial—a sculpture of Anna, seven feet tall, of solid bronze and weighing more than twelve hundred pounds—was erected in Ashland, Pennsylvania. The inscription read, "A Mother is the Holiest Thing Alive."

Popular references to Anna and her famous pose are still ubiquitous. In 1982, *Newsweek* ran a cartoon cover image of an Anna-esque old lady in front of a computer screen over the caption, "Home Is Where the Computer Is." In 1996, a *New Yorker* cover showed another cartoon Anna sitting by the phone, waiting, one presumes, for her son to call home.

Mary Cassatt

(1844 – 1926)

Daughter of Katherine Kelso Johnston Cassatt

❧

LOUISINE HAVEMEYER, MARY'S GOOD FRIEND and frequent subject, declared that "anyone who had the privilege of knowing Mary Cassatt's mother would know at once that it could be from her and from her alone that she, as well as her brother A.J. Cassatt, inherited their ability." Louisine knew Katherine well, since Mary's mother was a part of her intimate circle. "Mrs. Cassatt had the most alert mind I have ever met. She was a fine linguist, admirable housekeeper, remarkably well-read, was interested in everything, and spoke with more conviction, and possibly more charm than Miss Cassatt." Katherine was as much a friend to Mary as she was to her mother—the generation gap was inconsequential.

In 1878, when Katherine sat for *Portrait of a Lady*, reading *Le Figaro*, she and Mary's father, Robert, had just arrived in Paris to stay with their artist daughter. Ostensibly, the portrait was made as a gift for Mary's brothers in Philadelphia. But the long quiet process of sitting was also the perfect way for Mary and Katherine to spend stretches of time alone together.

Although Katherine was a matron above reproach, she was very supportive of Mary's bohemian way of life—her choice to forego marriage and a family in order to make a career as a painter. In an 1891 letter, Katherine bragged that "Mary is at work again, intent on fame and money," and that her pictures of the previous year "were considered very fine by critics and amateurs, one of them could have been sold ten times but Duran-Ruel [Mary's dealer] said he bought it for himself—you will probably see it in New York next fall or winter."

Katherine Kelso Johnston was born in 1806 into Pennsylvania's landed gentry. She and

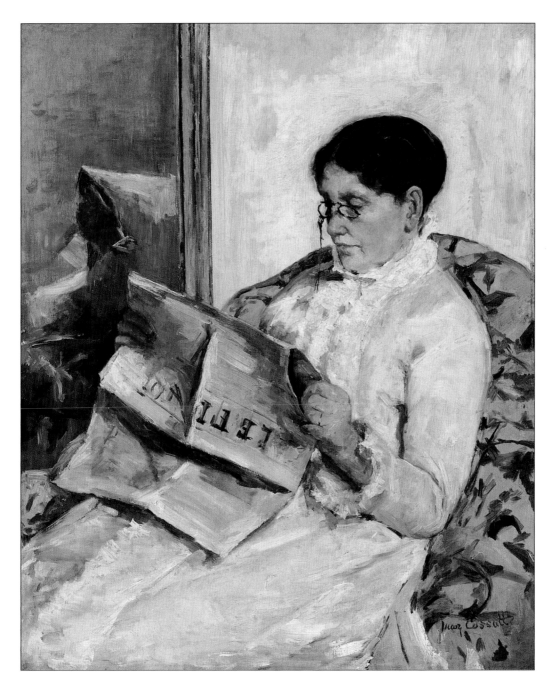

Mary painted *Reading* Le Figaro (or *Portrait of a Lady*) in 1878.

her husband, Robert, provided their children with an American pedigree of Dutch, Scottish, Irish, and French Huguenot blood that traced its roots to 1662. Katherine, who had been orphaned when she was sixteen, inherited considerable wealth from her late father and married Robert, a family friend, when she was nineteen. Katherine was poised and self-assured for her age, five feet six inches tall and in possession of an excellent European-style education. Robert was twenty-nine, already a daring entrepreneur with considerable self-made wealth and an old name. According to everyone it was an excellent match.

Mary was one of five children, although Katherine had also given birth to two other babies who died in infancy. Like so many women of her time, Katherine had to take the loss of her babies in stride and focus on the survivors: Lydia, born in 1837; Alec, born in 1839; Robbie, 1842; Mary, 1844; and Gordie, 1849. She had an extra burden to bear, however, when her son Robert, Mary's companion and the child closest in age to her, began exhibiting symptoms of a bone disease when he was eight years old. The disease was progressive, and he died at thirteen.

Because of her mother's love of European culture, Mary grew up to be fluent in French and German. Her father had retired very comfortably and very early to live on his capital, and he and Katherine decided to take their children on the Grand Tour.

Mary was tall, like her mother, and equally poised. In April of 1860, at fifteen, she realized that she wanted to be an artist and enrolled in the Pennsylvania Academy of Fine Arts. Most girls were at least eighteen before their parents grudgingly permitted them to study with young men (the Academy was coed), but Katherine and Robert had an enlightened, modern mindset.

Piety and revolt coexist in Mary's work. Her life was unconventional but her art celebrates Victorian womanhood, and, in particular, Victorian motherhood. Mary was a product of her own mother's tutelage, and Katherine was a consummate lady. The first biography of Mary ever published, in 1913, by Achille Segard, was entitled *Cassatt: A Painter of Children and of Mothers*. There is more to her long and varied career, but she never strayed far from home.

Despite the fact that Mary neither married nor had children, her affinity for them is clear. She celebrated the reality of motherhood—the struggle to comb a child's hair, to dress a sleepy head, to get a squirming toddler into the bath. What she captured with immortal tenderness and finesse are the sensual bond, and the spiritual devotion, of mater-

The Artist's Mother

nal love. Mary's many paintings of mothers and children drew mixed responses from her contemporaries. While some critics complained she was not sentimental enough, others hailed her realism.

In the same letter of 1891 quoted above, Katherine went on to write, "After all a woman who is not married is lucky if she has a decided love for work of any kind and the more absorbing it is the better." Mary had that love. Her spinsterhood also left her with the time and freedom to devote to her mother and sister. Although it is sad to think that Mary felt she had to choose between a domestic life and a career, it is happy to recall that she, unlike so many of her peers, could make that choice freely—and the world was not denied a magnificent body of work.

Katherine had a happy and peaceful fifty-six year marriage. Until her death in October of 1895, she was Mary's best friend and closest confidante.

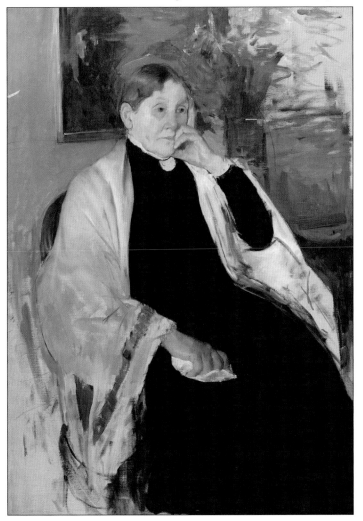

Katherine sat again for Mary in 1889 for this painting, which Mary called *Mrs. Robert S. Cassatt, the Artist's Mother.*

Henri de Toulouse-Lautrec

(1864 – 1901)

Son of Adèle de Toulouse-Lautrec

EVERY AFTERNOON, HENRI MARIE RAYMOND, the Vicomte de Toulouse-Lautrec-Montfa—or, as his mother called him, Henry—would spend several hours at a bar in Montmartre. Then, as evening fell, he would head to his studio to bathe, change out of his often outrageous daytime outfits into a conservative suit, and present himself at his mother's house for dinner.

Henry and his mother, the Comtesse Adèle, had a close and fiery relationship. Henry called his mother "Maman" to her face and "Adèle" behind her back, but as sarcastic as he might have been about the lady, he was quite lost without her. From the time he was an infant to his last years, Henry would fall into a state of despair when his mother went away. In a letter he wrote to her at eight, when she had left him to attend a wedding, he expressed the feelings that he would always nurture toward her his entire life: "I had no idea how much it hurts to be separated from one's mother." He signed the letter, "Your dear Coco."

Try as he might distance himself from his noble family, Henry could not separate from Adèle. While he passed his days cavorting with bohemian friends, dressing clownishly, drinking himself into oblivion, and painting can-can dancers and music hall stars, he still returned to his mother in the evening to give a tame report of his doings. When they were apart, he wrote her long, elaborate, and untruthful letters about his "respectable" pursuits. He couldn't bear to disappoint her.

Henry and Adèle needed each other and each was the central fixture in the other's life. Having been all but abandoned by Henry's father, Alphonse, Adèle devoted herself to the care of her son. Henry was a sickly child, and although it was years before doctors realized

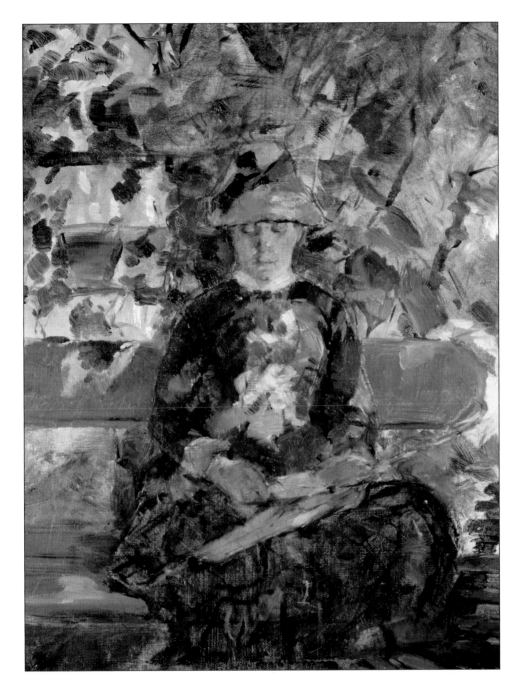

Comtesse Adèle de Toulouse-Lautrec, the Artist's Mother, 1882.

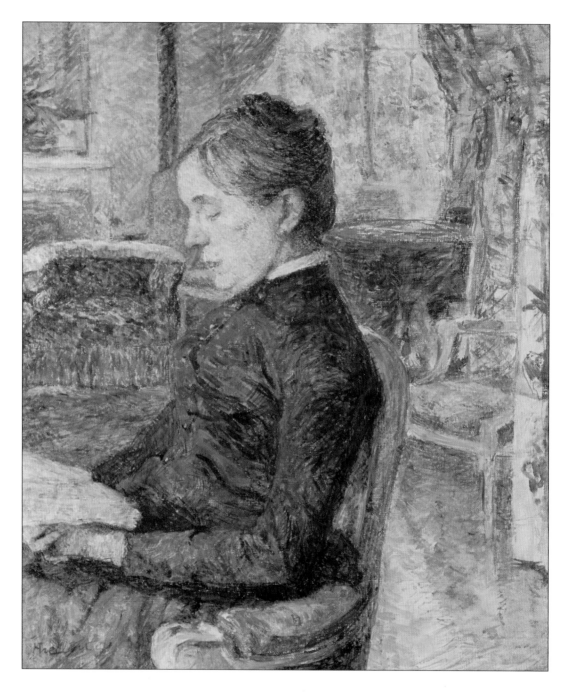

The Comtesse Alphonse de Toulouse-Lautrec in the Salon of the Château de Malromé, 1886.

that he had a growth disorder, it was clear from his infancy that there were problems with the development of his legs and feet. As an adult, Henry had the mind of a genius trapped in a grotesquely disproportionate body. He grew up to be tiny and malformed, with the torso of a grown man, stunted legs, and bony knobs all over his limbs. His bones broke easily, and among the other manifestations of the disease—a glandular malfunction—were bulbous lips, which caused him to drool and lisp.

With the hindsight of a modern diagnosis, it seems obvious that Henry's condition was a product of inbreeding—his parents were first cousins. In the nineteenth century, the French nobility often intermarried to keep bloodlines pure, and to keep property in the family. His father's sister married his mother's brother, and of their fourteen children, three exhibited the same abnormalities as Henry's in an even more serious form.

But the union of Alphonse and Adèle was not simply a marriage of convenience. Although he would abandon her for his hunting lodge, and his womanizing, Alphonse had, at first, loved Adèle feverishly. He called Henry the "fruit of the violent passion of real lovers." The violent passion produced a prodigy, the couple's only surviving offspring, who was plagued by constant pain, bone atrophy, and severe headaches. Henry's condition humiliated him. He wore layers of bulky undergarments to disguise his shape as much as possible— and his deformities contributed to his reckless living. A prolific popular painter who is perhaps best remembered for his Moulin Rouge posters, Henry died at thirty-six, his psyche betrayed by his body.

After Henry's death, Alphonse declared that he had never thought his son had much talent. He dismissed Henry's enormous body of exceptional work as "rough sketches." Adèle, on the other hand, lived until 1930 and devoted the rest of her life to championing her son's genius. She endowed the Musée Toulouse-Lautrec in the city of Albi, the family seat. It houses many of Henry's most famous and iconic works.

Marie Louise Catherine Breslau

(1856 – 1927)

Daughter of Katharina Freiin Wroclaw

❧

Portraitist Louise Breslau was born in Munich in 1856 into a wealthy middle-class family. She spent her childhood in Zurich, where her father was a well-respected surgeon. Louise was an asthmatic, and as a child she took up drawing so that she had something to keep her busy on days she was not well enough to leave the house.

Louise's father died when she was only ten, at which point her mother, Katharina, took charge of her education as an artist. Katharina sent Louise to a convent in Switzerland where she could recover her health and devote herself to developing her gift for drawing. Her time at the convent was a formative period in Louise's life—she flowered into an artist, there. But Katharina also realized that if her daughter was realize her dreams of a career, she would have to leave Switzerland. Mother and daughter moved to Paris so that Louise could attend the Academie Julian.

This tranquil double portrait of Katharina and Louise's sister Bernardina was exhibited at the Salon of 1885. It has become her most famous work.

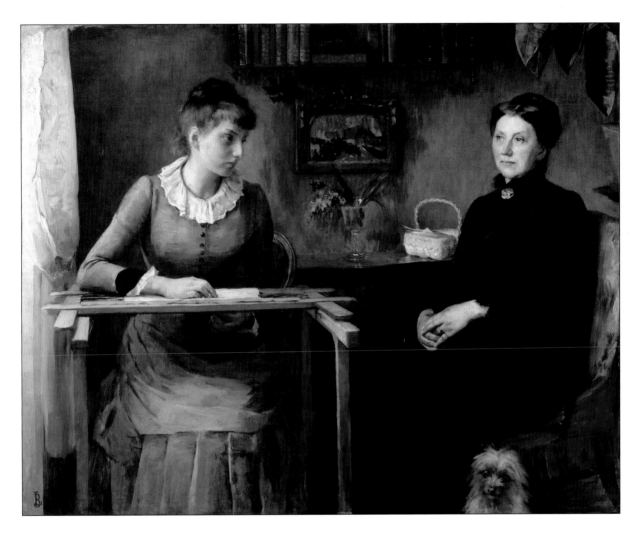

At Home, or *Intimacy,* a portrait of Louise Breslau's mother, Katharina, and her sister, Bernardina, painted in 1885.

Jacques-Émile Blanche

(1861 – 1942)

Son of Rose Blanche

❧

JACQUES-ÉMILE BLANCHE WAS AMONG the most prominent French painters at the turn of the twentieth century. He was well-known for his technical mastery and for the paintings he exhibited each year at the Paris Salon, starting in 1890. He was also at the center of an artistic circle in France and England whose members included Édouard Manet, Edgar Degas, Marcel Proust, Aubrey Bearsley, John Singer Sargent, James Whistler, Oscar Wilde, and Virginia Woolf.

Although Jacques-Émile was largely self-taught as a painter, he had the benefit of a superior classical education and of his parents' excellent connections. This portrait of his mother was painted in 1890, just before his breakthrough to widespread commercial success and critical acclaim. The soft, impressionistic details of the flowers around Madame Blanche are a metaphor for the tenderness which Jacques-Émile painted her face.

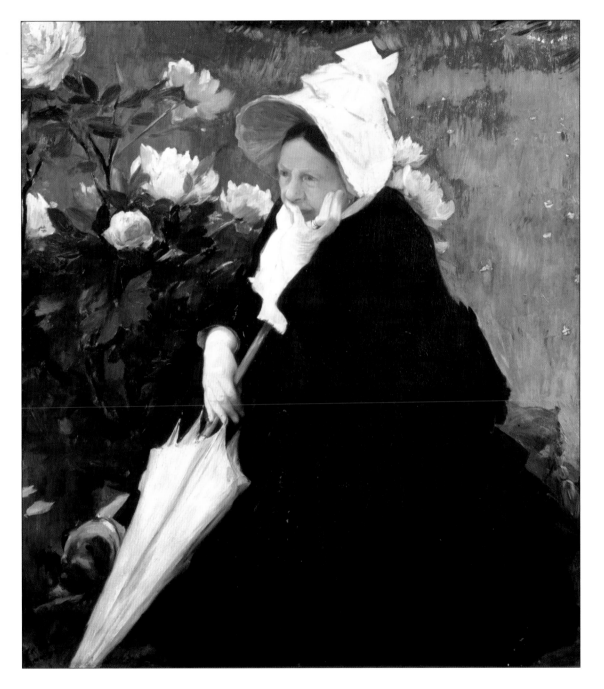

Portrait of the Artist's Mother was painted in 1890.

Henry Ossawa Tanner

(1859 – 1937)

Son of Sarah Elizabeth Miller Tanner

❧

IT IS NO COINCIDENCE THAT, IN THIS PORTRAIT, Sarah Tanner sits in a shadowy rocking chair in a plain, nearly unfurnished room, her pensive profile facing the left side of the painting. Henry Ossawa Tanner, her oldest son, was offering a response—even a challenge—to James Whistler's famous "Mother." Sarah's face, unlike Anna Whistler's, is nearly photographic. Although her pose seems almost childlike, Sarah would have been at least sixty when she posed for Henry, and there is something deeply expressive about her face. While much of the painting is in shades of brown—monochromatic enough to have pleased James Whistler—Henry did not choose to call this painting *Arrangement in Brown*. He also chose to illuminate Sarah's face, which becomes the glowing focus of the entire painting.

What also comes through in Henry's portrait of his mother is a fact that he alluded to only rarely in his painting—he, and his mother, were African American, and both faced prejudice all their lives. Although Henry was born into a comfortable and free middle class home, Sarah had been born into slavery in Virginia, the granddaughter of the white plantation owner to whom her parents belonged. At some point in her childhood, Sarah was taken north on the Underground Railroad and so managed to spend at least some of her youth in freedom, but she was separated forever from her parents. In the North, Sarah created the nuclear family life that had been denied her and her parents. She found a husband whose diaries demonstrate his commitment to her and to their children, whose love for her was equaled only by his love for God, and who worked tirelessly to support her.

Portrait of the Artist's Mother, which Henry kept for his private collection, was not created specifically to critique the academy, but into it he slips a reminder of his own heritage. Although Henry was determinedly non-confrontational, and never drew attention to the

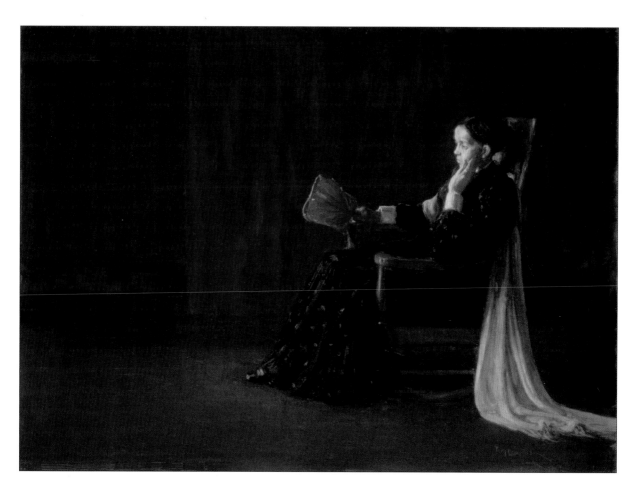

Henry Ossawa Tanner's *Portrait of the Artist's Mother*, 1897.

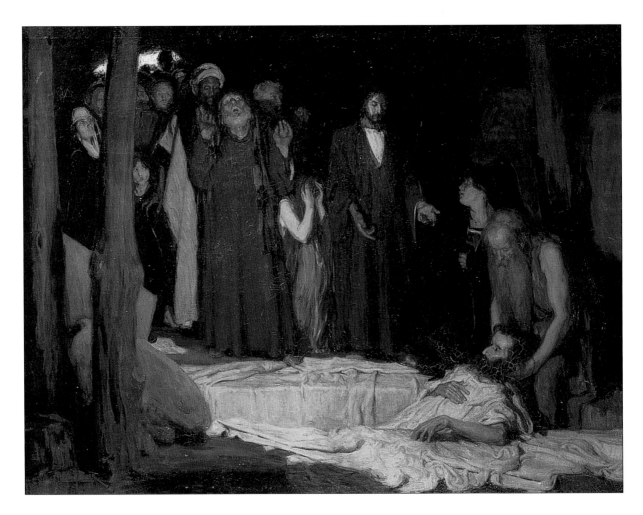

The Resurrection of Lazarus, 1897, is one of Henry Ossawa Tanner's many famous biblical paintings.

The Artist's Mother

racism he experienced, the fact remains that he was an African American man working to excel in a white profession in a country that had only recently banished slavery and still practiced systematic racial oppression. In his autobiography, Henry wrote, "I was extremely timid and to be made to feel that I was not wanted, although in a place where I had every right to be, even months afterwards caused me sometimes weeks of pain. Every time any one of these disagreeable incidents came to mind, my heart sank, and I was anew tortured by the thought of what I had endured, almost as much as the incident itself." He would eventually flee Pennsylvania for France, a more hospitable environment and a hotbed of expatriate American artists, in order to escape the racism of post-Civil War America.

Generally, Henry stuck to classical themes: biblical scenes, landscapes, buildings, animals, and people (often white people) at work. Although early in his career he created some compelling "black genre paintings," he also painted the kinds of subjects of interest to other masters (and collectors) of his day.

Henry had decided to become a painter when he was thirteen. He read critics who said America needed, variously, a great contemporary maritime painter, or a painter of animals, so he spent his time carefully observing the work of great maritime painters, or, alternately, at the zoo. In the beginning, Henry was almost entirely self-taught, and the attention to detail that distinguishes his work was less the product of formal training than of a keen eye.

Although Sarah and her husband, Benjamin Tucker Tanner, were both highly educated middle-class professionals (he was a minister at an African Methodist Episcopal Church, and she was a schoolteacher) they weren't affluent. Benjamin was the third generation of a free black family that had settled in Pennsylvania. His grandfather had been noted in the 1800 census, the first to include black Americans. Benjamin had attended college, then gone to seminary. Nine children, however, were a financial strain. Originally, Henry was sent to work in a flour mill to help support his younger siblings. His health deteriorated almost immediately, so his parents took him out of the mill and decided to do everything they could to support his dreams.

Sarah and Benjamin were Henry's first and most faithful patrons. When he saw a landscape artist at work for the first time, and became obsessed with the idea of learning to paint, Sarah lent him the fifteen cents he needed to buy his first colors and brushes.

Paul Gauguin

(1848 – 1903)

Son of Aline Maria Chazal Gauguin

PAUL GAUGUIN WAS PART OF a great revolution in art that took place at the end of the nineteenth century, and which ultimately legitimized all kinds of previously alien ways of seeing: the semi-abstract forms and kinetic energy of tribal art; the hallucinatory visions of madmen and dreamers; the intense colors of the tropics; images of otherness imported to Europe by adventurers and colonialists. Gauguin was inspired, he said, by his Peruvian heritage. He was born in Paris, but his mother, Aline Chazal, was half Peruvian; her mother was the prominent socialist activist Flora Tristan—a godmother of modern feminism. The Gauguins moved to Peru from France in 1851, and Paul would remember the three years he spent there as transformative both visually and spiritually. His work would borrow heavily from Peruvian culture and South American themes; he made prolific use of vivid primary colors—the colors of indigenous folk art—and of rain forest imagery.

Paul's father, Clovis, died during the journey to South America, and from the time that Paul was three years old, Aline was left to care for her two children alone. Because Flora Tristan believed that women needed autonomy, Aline had, as a teenager, been apprenticed to a dressmaker. As a result, she had a useful trade that enabled her to support her family, and the resourceful widow opened her own dress shop. Art ran in the Chazal family—Aline's father was a printmaker—and she was attentive to young Paul's education. After the family returned to France in 1855, she sent him to an elite secondary school near Orleans.

Paul worked at a variety of jobs after leaving school at seventeen. He enlisted in the merchant marine as a boat pilot's assistant, and later joined the navy. At twenty-three, he abandoned his military career to become a stockbroker. Painting was a hobby for him until he

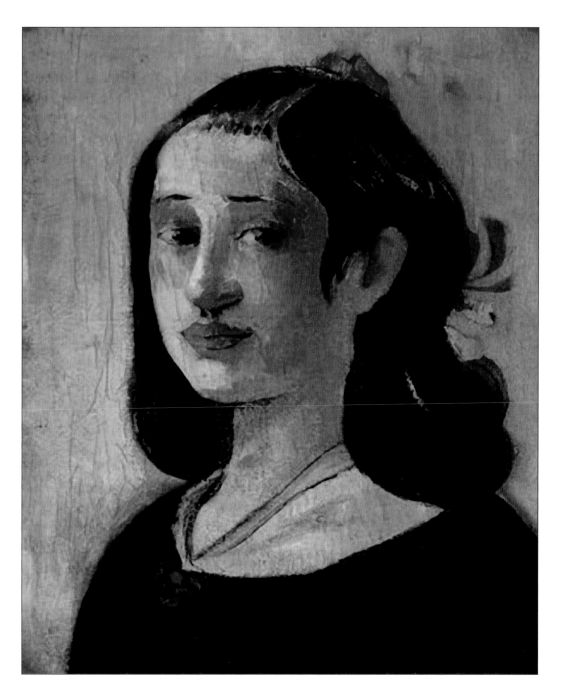

Paul Gauguin's *Portrait of Mother*, 1894.

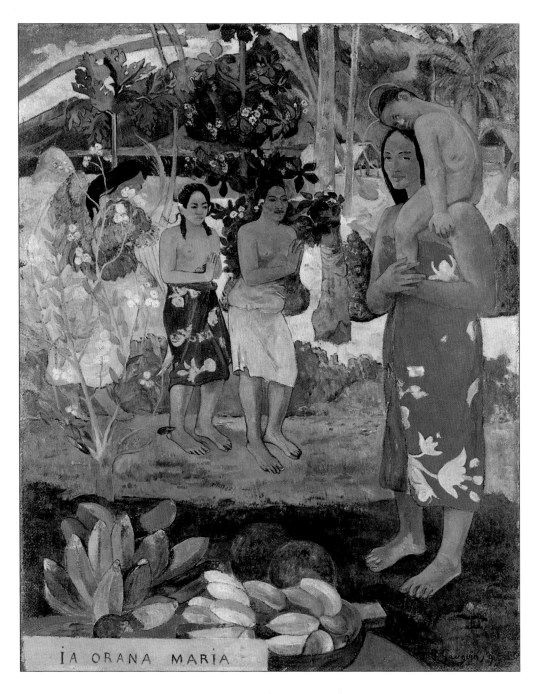

La Orana Maria, 1891 is one of the many paintings
Paul Gauguin completed in Tahiti.

The Artist's Mother

became friends with Camille Pissarro, who introduced him into Impressionist circles. In 1885, he gave up finance—and bourgeois life— to devote himself entirely to painting.

As his artistic philosophy evolved, Gauguin decided that Impressionism didn't offer him the depth of passion and expression that he sought to achieve. He began to focus on the art and symbolism of exotic cultures. In 1891, he left Europe virtually without a penny, and sailed to Tahiti via the Caribbean and Central America. He spent the rest of his life in Tahiti and the Marquesa Islands of French Polynesia.

Paul painted this portrait of his mother, Aline, in 1894, when he was far away on his island paradise. The painting, which was based on a cherished photograph, depicts Aline at fourteen.

Georges Seurat

(1859 – 1891)

Mother of Ernestine Faivre Seurat

🌿

Embroidery IS A MIMIC OF VERMEER'S CLASSIC *The Lacemaker*, which depicts a splendidly dressed young woman bent over her bobbins. Two centuries later, Georges Seurat recalled that glamorous young woman in a golden dress in this soft black-and-white portrait of his mother, the one constant and beloved figure in his short life. By depicting Ernestine Seurat this way, Georges was equating her with a masterpiece.

Ernestine was described by everyone who knew her as a patient, submissive wife, the pillar of the Seurat household, and Georges adored her. Although she had no formal education, she endowed her son with the family's appreciation for the arts. Her father had been a coachman who saved enough money to open a jewelry business. A maternal uncle introduced young Georges to painting, and other Faivres were artists, sculptors, and aesthetes.

Georges must have felt that he and his mother were quite alone in the world for much of his childhood. His father, an austere older man, was often absent, all but living at a villa in Provence, far from his wife and son, who remained in Paris. Georges's two siblings were thirteen and twelve years older than he was, so as a child he had Ernestine to himself. They had a very close relationship that lasted until his death at thirty-one. Ernestine died eight years later. Until the very end, Georges still dined with his mother most evenings.

Georges painted Ernestine on two other occasions. The last picture was completed between 1886 and 1888, and it shows Ernestine bent over a book. The first picture, which was perhaps a study for *Embroidery*, is called *Mme. Seurat, Mère*. Ernestine's head fills most of the frame. Its size suggests the outsized place she occupied in the artist's inner life and affections.

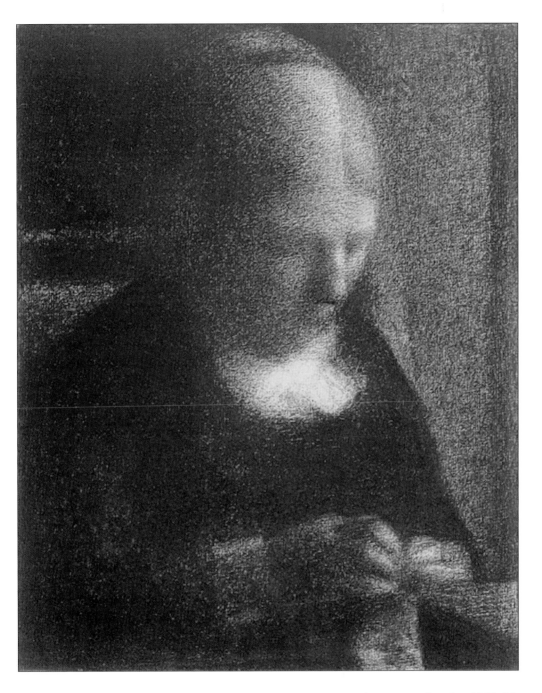

Embroidery (The Artist's Mother) was completed in 1882–83.

Vincent van Gogh

(1853 – 1890)

Son of Anna Cornelia Cerbentus van Gogh

IN A LETTER TO HIS BROTHER, THEO, an influential art dealer to whom he wrote nearly every day, Vincent van Gogh declared that he was painting this picture of their mother, Anna, for himself, because "I cannot stand the colorless photograph, and am trying to do one in a harmony of color, as I see her in my memory." The portrait was, in fact, painted from a black-and-white photograph, but color was Vincent's obsession, and he evoked his mother as he remembered her: vibrantly tinted.

Anna Cornelia Cerbentus van Gogh was a chubby, cheerful, and energetic woman, a perfect foil for her husband Theodorus, a cerebral minister. She was the daughter of a well-respected bookmaker in The Hague, and it is obvious from her letters that she possessed a lively mind. The van Goghs were married in Groot-Zundert when Anna was thirty-three and Theodorus was thirty. They were a very hard-working couple. Anna graciously made the rounds among Theodorus's parishioners in the tiny and provincial village to which they had moved. Her indomitable spirits buoyed the congregation during times of hardship, and she never let on if she felt bored, stifled, or oppressed by this limited world.

The van Goghs had lost a son who was born exactly a year before Vincent. He, too, had been christened Vincent. Anna gave her new baby the same name—a morbid gesture, perhaps, but one that expressed her faith in hope, continuity, and renewal. In retrospect, the van Gogh family seems tragic, but the artist's childhood was far from unhappy. His parents had a comfortable situation, and enjoyed respect in their community. They encouraged their son to pursue his dreams.

Good-natured and sociable, Anna was well-suited to her role as a minister's wife. She was the social lynchpin of her circle, and a prolific letter writer—a habit that Vincent and

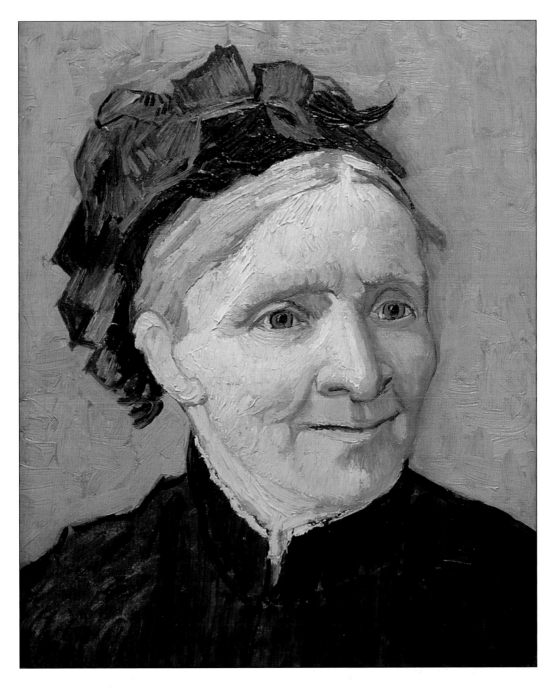

Vincent Van Gogh's *Portrait of the Artist's Mother*, 1888.

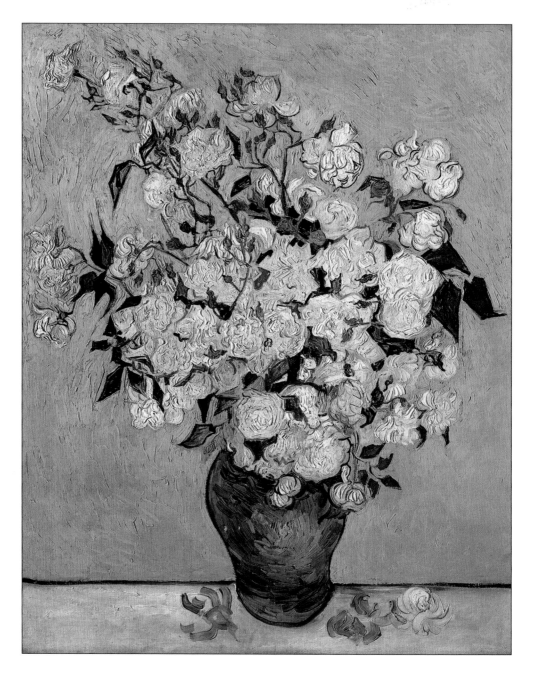

Vincent's flower-painting habit was the product of his mother's drawing exercises.
A Vase of Roses was painted in 1890.

The Artist's Mother

Theo inherited. Anna also saved all of her correspondence, and instilled this practice in her sons. Vincent and Theo had a rich, touching correspondence that offers us, a century and a half later, some insight into the workings of the artist's complicated and troubled mind.

Anna was a dutiful wife, but she had a rather unconventional hobby for the consort of a Protestant minister. She was an amateur artist, and a good one. She always found time for retreating to her quiet room, arranging a bouquet of flowers, and drawing it. In the course of his career, Vincent often channeled his mother's favorite subject: a monochromatic vase of flowers.

Anna was Vincent's first drawing instructor. He would sit on the floor and they would draw together. His childhood was defined by two forces, art and religion; his father was the agent of religion and his mother was the agent of art. Although Vincent would spend a decade following in his father's footsteps as a preacher and a missionary, it is, in the end, his mother's influence that helped him achieve greatness.

As he grew up, Vincent began the long epistolary documentation of his life that has inspired so many historians and art lovers. Many of his most tender and affectionate letters are to Anna. In 1889, he wrote about the burden of being apart from her: "As far as the sorrow, dear mother, is concerned, which we have and keep in separation and loss, it seems to me it is instinctive that we, without it, could not resign ourselves to separations, and probably it will help us to recognize and find each other again later."

Although he had been quiet and thoughtful as a young boy, Vincent's famously volatile temper began to assert itself during his early adulthood. It caused tension with his father, who had trouble dealing with his increasingly erratic and occasionally violent behavior. Both Anna and Theodorus were concerned and afraid for Vincent as his precarious mental state became apparent. But when his father would become angry and vengeful, threatening to cut Vincent off, Anna tried to run interference. As difficult as he was, she hoped to redeem her son, and to reel him back into the bosom of his loving family.

A bad accident brought about the reconciliation that Anna was hoping for. She fell from a train platform in January of 1884 and broke her thighbone. Vincent hurried to her side just in time to witness a traumatic scene: the doctor resetting the bone. Anna's pain was excruciating, and, watching her suffer, her son realized in a flash how much she meant to him. He vowed to nurse her back to health.

During Anna's convalescence, Vincent painted the house and its environs. This semblance of self-discipline and creative engagement with life encouraged his parents, who decided to support him with free room and board, hoping that the trend would become a habit. This happy arrangement was productive but short lived. Vincent eventually moved out again. He had grown quite remote by the time of his father's death, although his letters to Anna were still deeply affectionate. In September of 1889, he reached out to her again after a period of isolation, sending her a self-portrait for her seventieth birthday. In it, he depicted himself as he was in his early youth. That December, he wrote her a heartbreaking letter that makes it clear he was aware of his own mental illness, and that he was sorry for the grief he and his instability had caused her: "Often I have much self-reproach about things in my past, my illness coming more or less through my own fault… I think so much of you and the past. You and Father have been still more, if possible, to me than to the others, so much, so very much, and I seem not to have had a happy character."

Widowed and separated from her troubled son, Anna must have suffered terribly from her inability to be of help. From afar, though, she followed Vincent's career, rejoicing when his work was acknowledged as the revolutionary force it truly was. In 1890, an article by Albert Aurier, a young Belgian journalist, was published in the magazine *L'Art Moderne*. Aurier called Vincent a visionary destined to be misunderstood by anyone tainted by preconceived academic notions of what art was. Van Gogh might have outraged popular taste, but his art was pure— true artists and common people alike would see what the critics did not. Although Vincent would never enjoy the recognition in his lifetime, he would change the history and practice of art in a way only a few other creators ever have. Anna and Theo were in Paris when Aurier's article reached them. They read it together and talked late into the night about its implications for their beloved but stormy son and brother.

By this point, Vincent was beyond Anna's reach. She received what she labeled his "very last letter from Auvers" in July 1890, a few months after the publication of the article that declared Vincent a genius. In the letter he wrote: "Often I am thinking of you [and his sister] both, and should like very much to see you once again… I myself am quite absorbed by the immeasurable plain with cornfields against the hills, immense as a sea, delicate yellow, delicate soft green, delicate violet of a ploughed and weeded piece

The Artist's Mother

of soil… I am in a mood of nearly too great calmness, in the mood to paint this." He sent the letter only days before he walked into the cornfields and shot himself.

Anna died in 1907 at eighty-seven, outliving most of her children. Vincent was not the only tragedy in her life—Theo died at thirty-three. But until the end, she was a faithful patron of her son's art, the bedrock of his love for painting, his first teacher and his first inspiration.

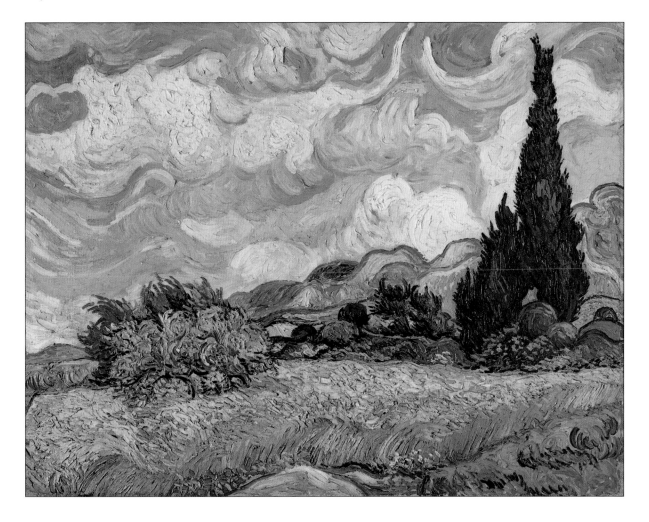

Vincent wrote to his mother about his obsession with the colors of the fields and skies.
This painting, *Wheat Field with Cypresses,* was finished in 1889.

Charles Camoin

(1879 – 1965)

Son of Marie Legros Camoin

❧

CHARLES CAMOIN WAS A FRIEND and contemporary of Henri Matisse, and, with Matisse, André Derain, Raoul Dufy, Kees van Dongen, and Georges Roualt, a member of the Fauvist movement. "Fauve," in French, means "wild beast," and the Fauvists—a brief-lived avant-garde at the last fin de siècle—were known for their uninhibited use of color, their thick, expressionistic brush strokes (which struck the contemporary eye as savage or frenzied), and for their primal, semi-abstract forms that anticipate the more somber work of the Cubists.

Charles painted his mother on many occasions—she was, like so many artists' mothers in this book, his emotional lodestar. His father had died when he was six, and his mother, who raised him almost single-handedly, was the sole sponsor of his education. When he was still a teenager, Charles won a drawing contest, and Marie urged him to capitalize on the notice he received to advance his career. It was she who pushed him to enter Gustave Moreau's class in painting at the Ecole des Beaux-Arts, where he met Matisse, Albert Marquet, and other kindred spirits who helped to set the course of art for a new century.

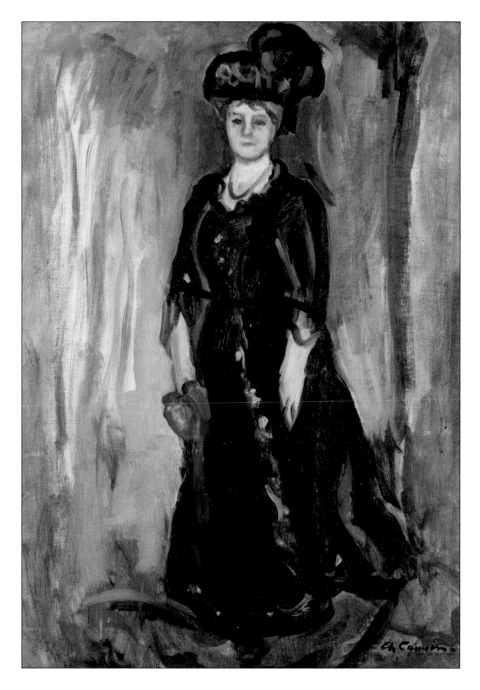

Charles Camoin's *The Artist's Mother*, 1905.

Fernand Léger

(1881 – 1955)

Son of Adèle Marie Daunou Léger

Fernand Léger was one of the most prominent artists of the early twentieth century. He was trained as an architect, and he supported himself as a draftsman before he became a painter. After serving in the army, he attended the École des Arts Decoratifs, in Paris—he had been rejected by the more prestigious École des Beaux-Arts—although he audited classes there. He was twenty-five by the time that he began to establish his name as a painter, and to create a distinctive signature. At that point, he jettisoned the Impressionist technique, palette, and imagery that had characterized his early work. He turned, instead, to a vocabulary of hard-edged, geometric forms, in primary colors, and pioneered his own muscular, Cubist style (affectionately dubbed "Tubism"), which featured tubular, conical, and cylindrical abstractions, and jazzy asymmetries, which alluded to the mechanized era that was dawning.

This portrait of his mother, which he called *The Seamstress* (*La Couseuse*), is an early example of Fernand's bold new direction. Despite its mathematical reductiveness, there is something still radiantly human—and intimate—about the seamstress's face.

The Seamstress, 1909, is Fernand Léger's portrait of his mother.

Mark Gertler

(1891 – 1939)

Son of Kate "Golda" Berenbaum Gertler

❧

MARK GERTLER WAS A TRAGIC FIGURE, who committed suicide at fifty, but, as a brilliant working-class artist, he was charismatic (and exotic) to his patrician contemporaries, and a member of the Bloomsbury circle. He figures as character in several novels by celebrated friends: *Women in Love*, by D.H. Lawrence; *Chrome Yellow*, by Aldous Huxley; and *Mendel*, by Gilbert Cannan, which alludes to Gertler's unrequited passion for the artist Dora Carrington, another central player in the Bloomsbury drama. If his life has left its mark in literature, his painting has left its mark on art history. He is famous for his fusion of Cubism and Realism.

Mark's parents, Golda and Louis, were immigrants to England from Przemysl, in Galicia, then a part of the Austro-Hungarian Empire. It was one of the poorest regions in Europe, with the lowest life expectancy. Golda had married beneath her. Mark's father was a peasant, but she had been born into a middle-class family, and she was a well-educated young woman, fluent in several languages, with a reverence for cultivation. Mark was the youngest of five children, and by the time of his birth, the Gertler family was living in the East End of London, a seething slum where many Jewish immigrants from the shtetls of Central Europe had settled. The family shared a house with twenty-six other people. When Mark was two, his father left the family to seek his fortune in America, effectively abandoning Golda to raise their children on her own. She was far too poor to have paid the tuition for Mark's education, but he successfully applied for a grant from the Jewish Education Aid Society, and he was able to enroll, at seventeen, in the prestigious Slade School of Art. His talent and ambition triumphed over his impoverished background, and he distinguished himself at the Slade. His mother was the subject of many early paintings. It was not long before Gertler had a following. Lady Ottoline Morrell, the eccentric Bloomsbury hostess, was an early collector and patron, and Winston Churchill's private secretary paid Gertler a monthly retainer for the first right of refusal on his new paintings.

In this 1911 portrait, Golda returns her son's gaze with a wary and penetrating expression, but it also captures the solidity which had anchored him. The picture was widely admired by Gertler's contemporaries, and it is still one of his best-loved works, even though—or perhaps because— it is so atypically naturalistic and emotional. The sitter bears an uncanny resemblance to images of the son from the same period. Thus did the artist express his visceral sense of closeness to, gratitude for, and identity with the woman who had sacrificed so much for him. "Her entire happiness is bound up in my progress," he wrote.

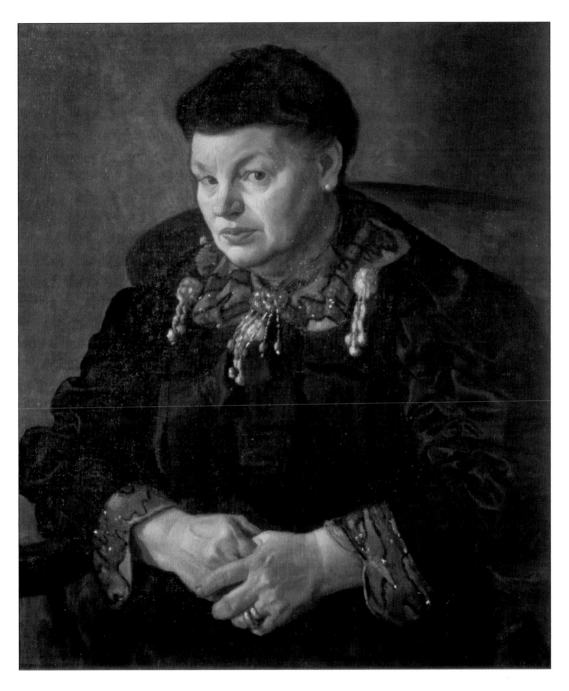

The Artist's Mother is one of two paintings Mark Gertler completed with this title.
This traditional treatment of the subject was completed in 1911;
another cubist treatment was completed in 1913.

Umberto Boccioni

(1882 – 1916)

Son of Cecilia Forlani Boccioni

🌿

U MBERTO BOCCIONI WAS A LEADING FIGURE and theorist of Futurism, an avant-garde move-
ment in art, literature, and politics that flourished in Italy at the last fin de siecle. The
Futurists were inspired by the technology of a new century. As Marinetti put it in the "Fu-
turist Manifesto," published in 1909, "the world's magnificence has been enriched by a new
beauty: the beauty of speed…a roaring car that seems to ride on grapeshot is more beau-
tiful than the *Victory of Samothrace*." Boccioni's painting and sculpture rejected conventional
notions of beauty to celebrate the modern world.

Materia is perhaps Umberto's most famous painting. It was completed at the height of
his influence, four years before he died, at thirty-four, during the First World War, trampled
to death by a horse. It was also the centerpiece and title picture of a Boccioni retrospec-
tive at the Guggenheim Museum, in 2004. Its subject is Umberto's mother, Cecilia, on the
balcony of her apartment in Milan. Behind her, illuminated by shafts of sunlight, is the frag-
mented skyline of an industrial city. The sitter has the gray hair and wrinkles of an elderly
woman, but she also has muscular arms and a strong, solid body. Her hands are the focal
point. They are clasped in her lap, maternally, but they are also large and capable—the tools
of hard work and creative force.

A year later, Cecilia posed for a sculpture that Umberto titled, rather ungallantly, *Anti-
graceful*—though he was using his mother's form as metaphor for strength, and for his own
emphatic rejection of sentimentality. (She is not, one should not, "ungraceful," a failing. She
is "antigraceful," a dynamic posture of revolt.) But he also did many more traditional por-
traits, etchings, and drawings of his mother in domestic settings, including a triptych from
1907-8, *Homage to the Mother*. He painted her sewing, crocheting, and reading at a table. His

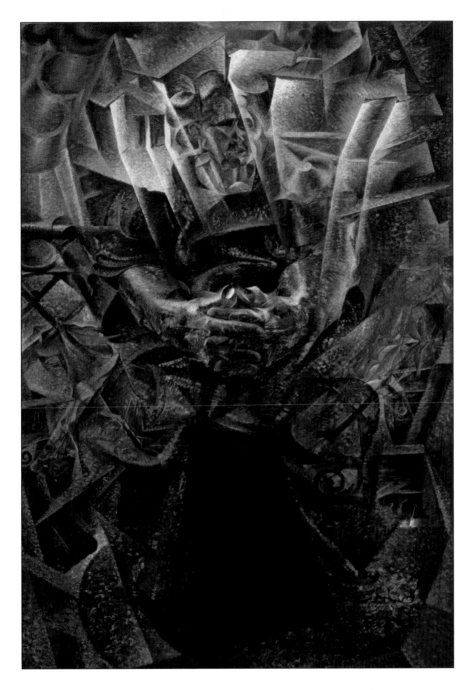

Umberto Boccioni's *Materia,* 1912, is one of many portraits
the artist made of his mother.

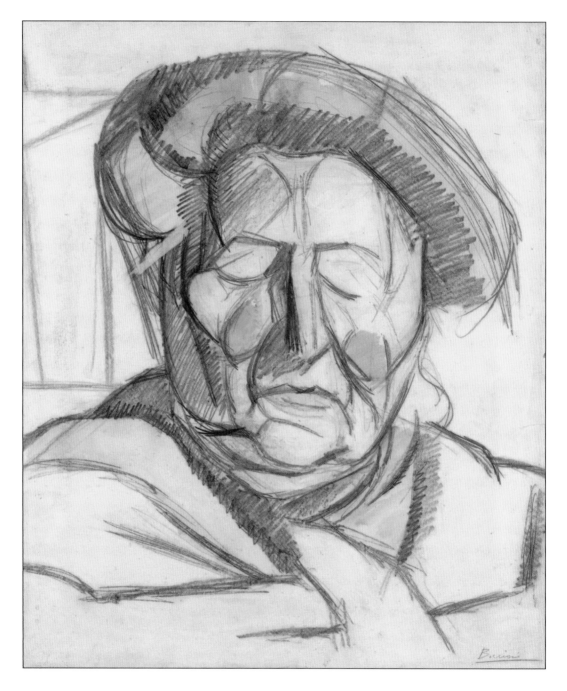

The Artist's Mother is a pen-and-ink drawing
that Umberto Boccioni completed in 1915.

feeling for Cecilia comes through both in the warmth and detail with which he observed her, and in the frequency with which she posed for him in the span of his short career.

The Futurists exalted war as an agent of social change, and some members of the movement become Fascists in the decades that followed. Umberto—and his beloved mother—were spared that disgrace.

Philip Alexius de László

(1869 – 1937)

Son of Johanna Laub

Philip de László called this portrait of his mother, Johanna Laub, "the very best I have ever painted." He put the finishing touches to it in February, 1914, when she visited him in England. From there, they left for France together on what proved to be a last holiday before World War I. Johanna was seventy-five, but Philip probably didn't imagine that this was their final encounter. He couldn't have known that his native country, Hungary, would suddenly become an enemy of his adopted country, England; that his assets would be frozen when Austria seized his bank account; or that he would then have to risk deportation and imprisonment to send Johanna an allowance via friends in Holland.

For the rest of his life, Philip kept the portrait of Johanna for inspiration while he painted. "In my studio there stands on my easel the last portrait of her which I was so happy to paint last year," he wrote to a friend in 1915. "And so I am not alone."

Philip idolized his mother. In a pattern that repeats itself again and again as we look at the early lives of many artists, Philip saw his father as a distant tyrant and his mother, just as oppressed in their house as he was, as his beloved ally. One of his earliest memories was of sitting by the fire while she made clothes for her children on a sewing machine. This vignette, which Philip cherished and retold all his life, expresses the nature of their bond: her feminine devotion, and his protective, filial gratitude to the woman who had kept his life stitched together.

Johanna had raised the leading portrait painter in England at the turn of the last century. For thirty years, Philip's status was unchallenged. Among the celebrities he painted were the Queen of England, King Constantine I and Queen Olga of Greece, Popes Leo XIII and Innocent X, the Archbishop of Canterbury, Queen Louise of Sweden, King Alfonso XIII of Spain, Calvin Coolidge, Theodore Roosevelt, and Vita Sackville-West.

It was the painting of his mother, though, that was closest to his heart. He wrote to a friend, "I am so grateful to have painted her just last year—which will remain as a sign and example to my children's children of the most noble mother which ever lived."

Johanna Laub, the Artist's Mother was painted in 1914.

Giorgio de Chirico

(1888 – 1878)

Son of Gemma de Chirico

GIORGIO DE CHIRICO'S FIRST WIFE, Raissa, a Russian ballerina, had a private theory about her mother-in-law, whose background was mysterious. Baronessa Gemma de Chirico, Raissa decided, must have been some kind of cabaret artist before her marriage, traveling from city to city with an operetta troupe. The de Chiricos, an ancient family of Sicilian aristocrats, would have felt sullied by such a connection, had it been made public—even if it weren't true. But Raissa's only "evidence" for her slander was Gemma's famous love of jewelry, which she piled on with gypsy exuberance. Real or fake, it didn't matter: Gemma loved glamming it up, and dressed to the nines, she made her sons take her shopping.

Whether or not she ever sang in a music hall, Gemma was a theatrical character, (and her son took after her.) The de Chiricos were a passionate southern clan, and Raissa recalled escaping from the house during Gemma's frightful altercations with Giorgio, only to return an hour later to find the two of them drinking coffee amicably and chatting as if nothing had happened. Raissa would also recall that her husband was always looking for a woman to boss him about, and in that respect, Gemma, never let him down.

Gemma was a force to be reckoned with, who felt free to drop in on her adult sons uninvited, and to stay for any length of time, telling them, like small boys, how to dress for dinner. She was also an aggressive advocate of Giorgio's career. When her husband died, she decided that her sons could best continue their studies in art abroad, so she trundled them off to Munich, where Giorgio spent six years, between twelve and eighteen. When he and his brother Alberto joined the army during World War I, Gemma followed them to Ferrara, where they were stationed, and rented a house there. Instead of camping in the barracks, they lived in bourgeois comfort, enjoying the Baronessa's delicious meals and stylish décor, and focusing on their respective arts even though a war was raging. Giorgio made great strides as an artist during that period: serving the motherland, and being served by the mother.

The Baronessa evidently possessed a powerful allure for the opposite sex. Two de Chirico men had competed for her favor, and Evaristo, Giorgio's father, outplayed his brother, Alberto, to win her hand. Did she beguile them with charms learned in a harem? (According to another rumor, Gemma was part Turkish.) Whatever the truth, she was a force to be reckoned with, and Giorgio, who was smitten by his mother, painted her many times. In this surrealist image, she sits at a window, just as she does in an earlier, realist painting. Here, however, he paints himself outside the frame, looking away from her pensively. A viewer can't help but notice the similarity between their profiles. A strong nose, however, wasn't her only legacy. Gemma's mystery pervades Giorgio's work.

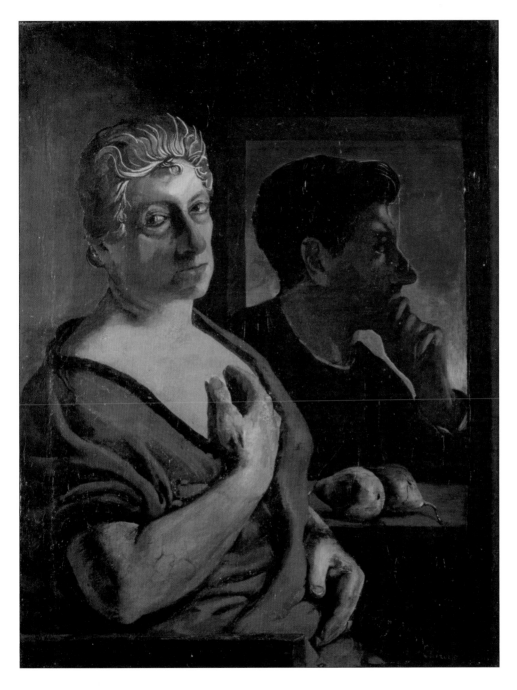

Georgio de Chirico's *Portrait of the Artist and His Mother*, 1919.

The Artist's Mother

George Wesley Bellows

(1882 – 1925)

Son of Anna Smith Bellows

GEORGE BELLOWS' FATHER WAS FIFTY-FIVE when George was born, and it was, perhaps, natural for him to feel much closer to his young mother. Anna was a devout Methodist, so play and frivolity on the Sabbath were forbidden; kept indoors, George took up drawing. As he grew up, the seething, visceral real world beyond Anna's lace curtains beckoned to him. He became an artist who celebrated urban life: street urchins, skylines, kids swimming in New York's East River, and the homeless. One of his most famous paintings, *Stag at Sharkey's,* depicts a boxing match.

By the time he was in college, George was already a sought-after illustrator, and after graduating from Ohio State University, he left for New York, where he became a founding member of the Ashcan School. By twenty-three, he had been admitted into the National Academy of Design. He was only thirty when his first painting was acquired by by the Metropolitan Museum of Art. By the time he died, at forty-three, of a ruptured appendix, George had created a large and diverse body of work: paintings, lithographs, and illustrations.

This painting of Anna is almost seven feet tall and more than four feet wide. Its size suggests—for better or worse— the scale of her place in his imagination.

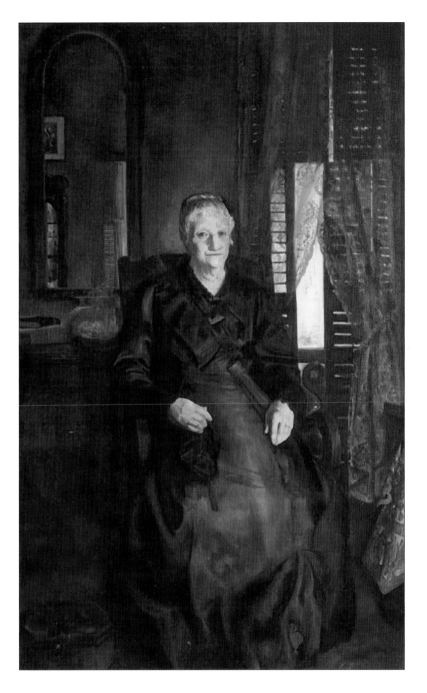

My Mother, painted in 1921.

Pablo Picasso

(1881 – 1973)

Son of María Picasso y Lopez

ACCORDING TO HIS MOTHER, Pablo Picasso's first words were "*piz, piz*"—Spanish baby talk for *lapiz*—a pencil. No baby would have been likelier to demand a drawing implement than the first-born child of Don José Ruiz y Blasco and his wife, María Picasso y Lopez. Don Jose, the descendent of minor aristocrats, was an art teacher and a museum curator in Malaga, and a successful painter in his own right. Pablo was surrounded by colors, brushes, canvas, and pictures from infancy, and very soon, began making his own.

Don Jose gave his precociously gifted son drawing lessons at seven years old. By eleven, young Pablo already had a mature technique. It wasn't long before the father realized that he had been eclipsed, and in deference to the boy's obvious genius, he devoted himself to his son's career. María contributed her name to it—a name that is to art what "Mozart" is to music, "Bernhardt" to theater, and "Einstein" to physics. In 1901, Pablo began signing his work, "Picasso."

But María was, in her own right, also a major sponsor of Pablo's career. She was many years younger than her husband, and the family dynamo: a small, practical woman whom Pablo described as cheerful, stable, and lovable. Both parents were tolerant of their son's sometimes eccentric tastes and passionate behavior. Many geniuses grow up to feel freakish or estranged, but Picasso's parents perceived—and nurtured—his originality. (It is comforting to think, however, that not everything came easy to this Protean figure: his father once had to pull strings to save Pablo from failing math.) What did come easy, though, were Don Jose's guidance, and Maria's love: they both encouraged their son to follow his heart.

It was, in fact, María who urged Pablo to leave Spain for Paris, the center of the art world, and the best place to continue his studies, even though his departure strained the family's finances. Don Jose, who had wanted Pablo to stay in Malaga, and become an aca-

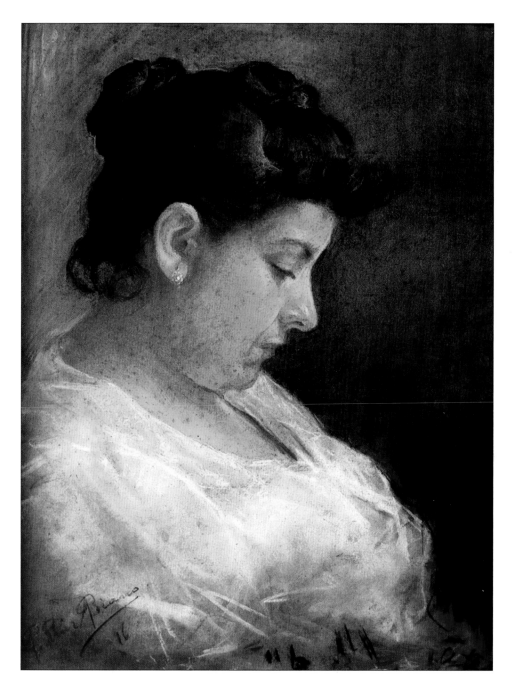

Pablo Picasso first painted his mother in 1896,
when he was only fifteen years old.

The Artist's Mother ℘ 97

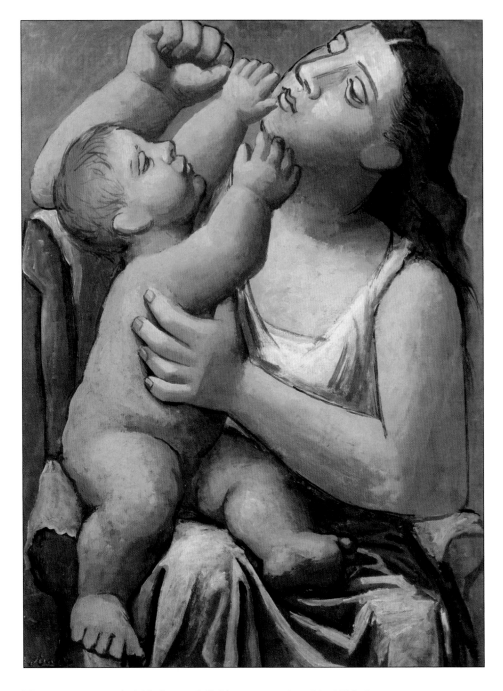

This painting, entitled *Mother and Child*, was completed in 1921–2.

demic, as he was, finally backed down when he realized that his wife and son were of one mind.

María would tell Gertrude Stein that Pablo was "an angel and a devil in beauty, and no one could cease looking at him." María was clearly besotted with her son, however unmanageable he could be. She did not have her husband's critical training, but she did have the uncritical faith that her child could achieve any goal he set. "When I was a child," Picasso said, "my mother told me, 'If you become a soldier, you'll be a general. If you become a monk, you'll end up as the Pope.' "

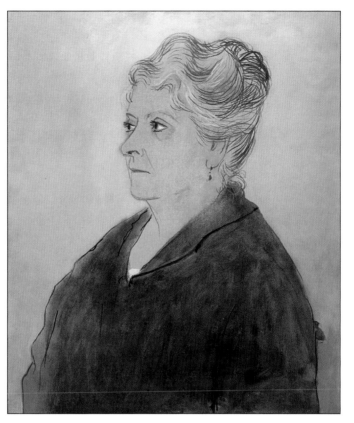

Pablo Picasso's second portrait of his mother, completed in 1923.

Picasso loved, lived with, and left many women, and married two of them. He chronicled his tumultuous romantic life in his paintings. But he also often painted mothers and infants, inspired, perhaps, by memories of his own mother and baby sister, Lola—one of his earliest models. Don Jose also figures in many of Picasso's early paintings and sketchings. But it was harder to get the energetic María to sit still, and most of his portraits show her engaged in some kind of domestic activity. He did persuade her to sit for two formal portraits: once, when he was fourteen, in 1896, and again in 1923.

Archibald Motley

(1891 – 1981)

Son of Mary Huff Motley

Before he achieved reknown as a painter of the Harlem Renaissance and its nightlife, Archibald Motley was a critically acclaimed portraitist. In the course of his long, groundbreaking career, Motley painted his mother twice. *Portrait of My Mother* was finished in 1919, during Archibald's final years at the School of the Art Institute of Chicago. It was the first picture that he exhibited as a professional, and his good friend Joseph Tomanek, a fellow student, framed the canvas himself, so Archibald, who couldn't afford the materials, would be able to show it.

His second image of Mary Huff Motley, pictured here, *Portrait of a Woman on a Wicker Settee*, was completed in 1931, by which time Archibald's star was rising. He had married a childhood sweetheart, and they were living in Paris—a more hospitable place than America for interracial couples. Mary had come for a visit. She looks straight at the viewer with the same dignified but soft gaze that her son had captured a decade earlier.

Mary Huff Motley was a schoolteacher. Her son Archibald was born in New Orleans, on August 7, 1891, but two years later, the family embarked on a series of moves that brought them to Chicago. They were one of the few black families in a neighborhood that had been settled by northern European immigrants, but there were few racial tensions, and they felt at home. Their ties to Louisiana remained strong, however, and Archibald and his sister Flossie were sent back each summer. The Huffs were a proud family, and Archibald listened raptly to the oral histories and lore that were passed down to him. He was especially close to his tiny, maternal grandmother, Harriet Huff. At four feet, eight inches tall, she was described by Archibald as "a Pygmy from former British East Africa." Before the Civil War, Harriet had been a slave in Tennessee and Louisiana, and she made sure that her descen-

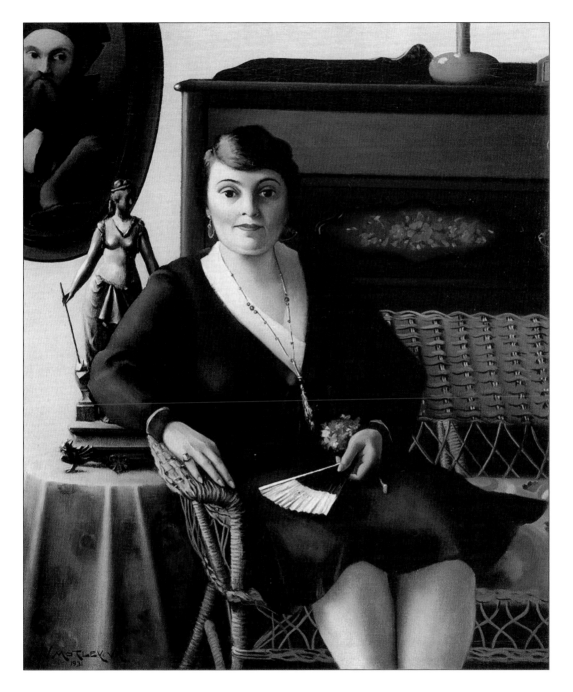

Mary Huff Motley posed for this 1929 painting,
Portrait of a Woman in a Wicker Setee, while visiting her son in Paris.

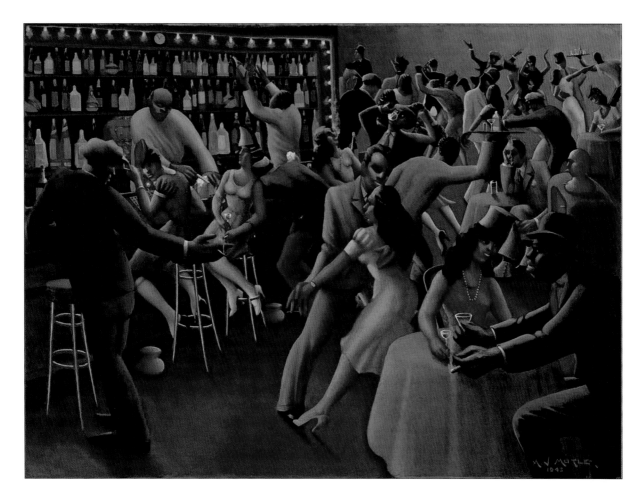

Nightlife, 1943, is perhaps Archibald J. Motley, Jr.'s most famous painting.

৵ The Artist's Mother

dents learned about their African and Creole heritage. Her influence would surface in Archibald's mature work, when he jettisoned the classical subjects he had studied in art school, and focused on African- American themes.

Archibald wasn't able to start high school until he was eighteen, by which point he had worked on the railroad, in a barbershop, and as a shoeshine boy, though he had always felt that art was his true calling. He was a gifted athlete who played on his school's football and baseball teams (he later had a brief, semi-pro career as a first baseman for the Royal Giants,) and he also began to date—secretly—a fellow student, Edith Granzo, his future wife—a white girl whose German parents were adamantly opposed to the notion of a black son-in-law. After high school, Archibald enrolled at the Institute, but for a decade after he graduated, he had to work as a plumber and a coal heaver—he couldn't get a job in the art world. His breakthrough came in 1924, with a portrait of his paternal grandmother. The painting was called *Mending Socks*.

Archibald would credit Mary with helping to cultivate his eye, and, in particular, to notice the subtleties of skin tone that distinguish his portraits of mixed-race models. Archibald was tired of seeing black Americans depicted as stereotypes. "This material is obsolete," he wrote, "and I sincerely hope with the progress the Negro has made, he is deserving to be represented in his true perspective, with dignity, honesty, integrity, intelligence and understanding. In my paintings I have tried to paint the Negro as I have seen him and as I feel him, in myself without adding or detracting, just being frankly honest."

Mary figures as a much cherished figure in Archibald's letters and diaries. Her company always gave him pleasure. When an interviewer later asked him what, exactly, he had accomplished in Jazz Age Paris, he replied, "I painted a beautiful picture of my mother."

Arshile Gorky

(1902 – 1948)

Son of Shushan Adoian

ARSHILE GORKY'S SELF-PORTRAIT as a young man standing next to his mother is probably his best-known painting. He worked from a black-and-white photo taken in Armenia in 1914, and painted this image at least twice. By 1925—the date of the first version—Arshile was living in America, and his mother had been dead for six years. She had succumbed to starvation March of 1919, during the last months of the Armenian genocide, having sacrificed her four-ounce ration of bread to keep her children alive. She died in her son's arms.

Shushan's ghost haunted Arshile all his life; he spoke and wrote of her reverently and tried to resurrect her on canvas. He had been abandoned by his father when he was too young to remember him, so Shushan was his only parent. Arshile (christened Manoug Adoian) was born in Armenia sometime between 1902 and 1904. The extermination of the Armenians by the Ottoman Turks began in 1914. Shushan was one of its two million victims. They died of starvation, typhus, cold, and exhaustion on forced marches, or they were slaughtered in militia raids on their villages.

The decades leading up to the genocide were a fraught period. Shushan's life story is exemplary. The daughter of an Apostolic Orthodox priest, she was married in 1894, at fourteen. Many Armenian parents married their daughters at puberty to protect them from being raped or abducted by the Ottoman troops. Shushan and her husband quickly had two daughters, but their happy family life was not to last. Vartoosh, Arshile's sister, would later relate the horrific story of Shushan's widowhood. In 1896, when she was sixteen, three Turkish guards stabbed her husband to death in front of her. One of the guards held Shushan and pulled back her eyelids so she had to watch.

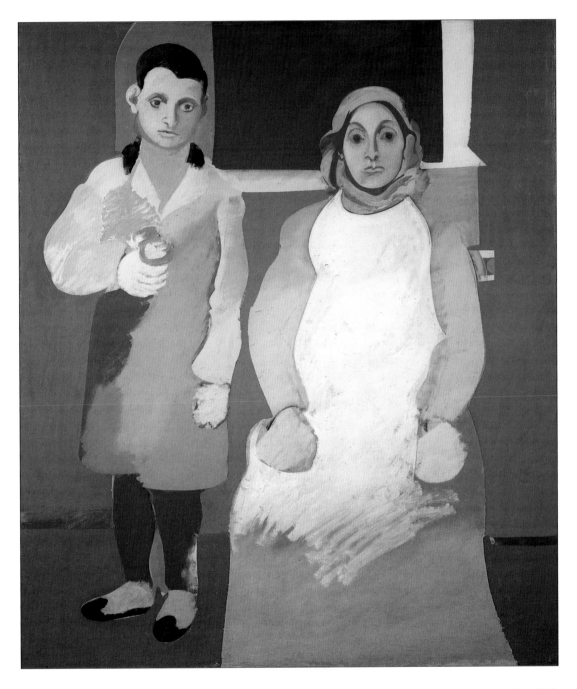

Arshile Gorky's *The Artist and His Mother*, 1925–1939.

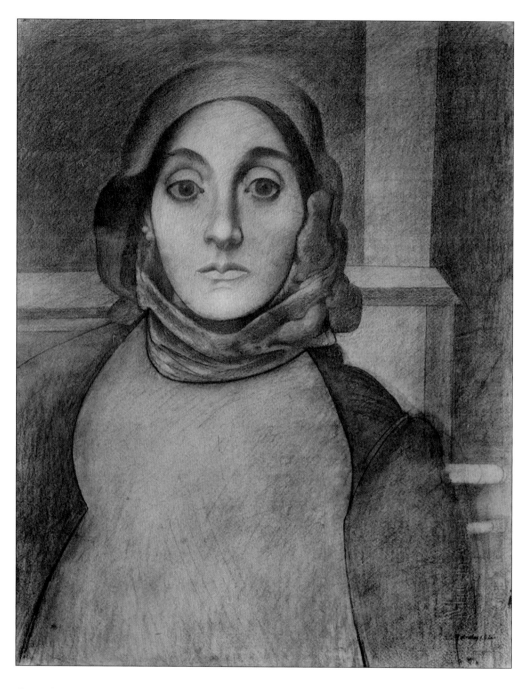

One of several black-and-white studies of his mother Arshile Gorky completed.

The Artist's Mother

Arshile's father, Sertag Adoian, was Shushan's second husband, one of the wealthier men in a poor village. It wasn't long, however, before Sertag fled Armenia to avoid the draft, and emigrated to the United States. He rarely sent money home, and Shushan supported the family by tilling the fields and tending the livestock. She was known as a great cook and an obsessive housekeeper. The neighbors are said to have laughed at how assiduously she scoured her pans. Shushan's nephew described her as a conventionally submissive wife who "always wore a [head] scarf," and was "modest and hardly spoke." Yet Shushan had a fighting spirit when it mattered.

Shushan was particularly protective of Arshile. She cemented their bond with motherly attentions but also with a sense of complicity that was more sisterly than maternal. In one famous story, Arshile stole some fruit from a neighbor's orchard, and Shushan had to hide him in her oven. In another tale, Shushan tricked Arshile, who was already three, into talking (he had refused to say a word). She pretended to jump off a cliff ledge, forcing him to shout, "Mother!" She also encouraged his interest in art from an early age, and made him fantastical toys of feathers and cloth that were, he boasted later, better than any sculptures of Picasso's.

Despite her poverty, Shushan managed to put aside some savings to buy Arshile his drawing materials. Both her eye and her pride were keen enough to perceive his raw talent, and she encouraged his drawing even when it interfered with his schoolwork. He was always in trouble for doodling or whittling in class, and even Shushan sometimes lost her patience with his with wild behavior.

Gorky's childhood and adolescence with Shushan in Armenia were, he felt, the "real" part of his life. He left for America the year that she died, and he never recovered from that double loss—of his mother and his country. Critics have called his portrait of Shushan an "iconic masterpiece"—a masterpiece by virtue of its formal power and purity and iconic by virtue of the timeless subject. The seated mother is a figure of radiant fortitude, and even though the pensive boy stands at a distance from her, the artist captured the nature of their profound attachment.

In America, Gorky redeemed the promise for which Shushan sacrificed so much. He became one of the greatest painters of his generation. But as he aged, he couldn't shake his grief, or his traumas. He would always be an exile, mourning the mother who had died for him. In 1948—at forty-four—Gorky hanged himself in his Connecticut studio. But Shushan's gift of life lives on his art.

Frida Kahlo

(1907 – 1954)

Daughter of Matilde Calderón y Gonzalez Kahlo

Frida Kahlo lived, painted, and mythologized herself both as a Mexican and as a woman. Her father's family were Hungarian Jews who had emigrated to Mexico from Germany, but her mother's family was the typical product of a New World intermarriage—half Spanish, half Indian. In a famous family portrait, which shows three generations of parents and children, Kahlo painted herself as a naked toddler still attached to her mother's navel by an umbilical cord.

Matilde Calderón y Gonzalez was almost thirty when Frida was born. By all accounts, she was a great beauty and a model of Catholic virtue—a devout convent girl, the oldest of twelve children. Her mother, Isabel Gonzalez, a former nun, was the daughter of a Spanish general. Her father, Antonio Calderón, was a photographer of indigenous descent who had achieved some prominence. After her marriage, at twenty-four, to Guillermo Kahlo, Matilde persuaded her bridegroom to become her father's apprentice. Antonio and his son-in-law travelled all over Mexico with their cameras and darkroom equipment, photographing native and colonial buildings. In four years, they produced more than than nine-hundred plates that illustrate the richness of Mexican architecture.

Guillermo had two daughters from an earlier marriage; he and Matilde had two more. Matilde raised all of them as she had herself been raised. They learned to cook, clean, embroider, and to run a big household; they were expected to be perfectly virtuous and devout. Frida referred to her mother as *mi jefe*, "my boss." Undeterred (or perhaps driven) by her husband's atheism, she marched the girls to Mass every morning. She was equally undeterred when Antonio's business failed, and he fell apart. "She wasn't literate," Frida wrote, "though she was very intelligent. "And when it came to money, she knew how to count."

Frida Kahlo's *My Grandparents, My Parents and I*, 1936.

The Artist's Mother 109

Frida contracted polio as a child, the first of the many traumas that she survived, triumphed over, and which influenced her art, even as they cast a shadow on it. The helpless invalid, confined to the house during her long convalesence, became unusually dependent on her mother, and even though Kahlo would later dramatically rebel against almost every traditional virtue that Matilde held sacred, she could never quite shake the yoke that bound them.

Although she enjoyed drawing and painting, Frida initially wanted to become a doctor. She enrolled in an elite medical school at fifteen. But three years later, in 1925, Frida was riding in a city bus that collided with a trolley car, and suffered excruciating and traumatic injuries: a broken back, pelvis, and collarbone; damage to her uterus, and a perforated stomach (run through by one of the bus's iron handrails.) Her right leg, already atrophied by polio, was fractured in eleven places, and her right foot was crushed. Although she was eventually able to walk again, she underwent more than thirty reconstructive operations, she would live with severe chronic pain for the rest of her life.

There was no question of finishing medical school after the accident. Immobilized, Frida took up painting. Pain, frailty, violence, and mutilation were recurring subjects. But art also led to love. Unsure of her talent, Frida sought advice from the renowned Mexican painter Diego Rivera. Their mutual passion was immediate, and they married in 1929, when Frida was twenty-two, and Diego forty-three.

The marriage was tumultuous and bohemian, and neither spouse was capable of fidelity. Although Diego tolerated Frida's affairs with men and women, his affairs made her jealous, and were the cause of frequent unrest in their relationship. She and Diego quarreled violently, reconciled, divorced, remarried, and, through it all, somehow remained soul mates, unable to do without each other. They were also true comrades in art and politics—both revolutionaries on different paths. Leon Trotsky, who had escaped from a Stalinist prison camp and was living in Mexico (where he was assassinated in 1940) was part of their inner circle of high-profile artists and radicals.

In 1932, Frida learned that her mother was dying of breast cancer. She was living in Detroit with Rivera, and she immediately set out for home, by train, hysterical the entire way. She had suffered a miscarriage that July, and, in her state of extreme agitation she began to bleed again. Matilde died a week after Frida's arrival, and Guillermo took a famous photo-

graph of her just after the funeral. In the picture, all the darkness of her spirit is clearly marked on her face.

Frida's second portrait of her mother dates from this period. She called it *My Birth*, and it expresses the twin losses of her mother and her unborn baby. A naked woman lies spread-eagled on a bed, in a largely empty room, an infant emerging between her legs. A sheet, like a shroud, is wrapped around the mother's head. The baby appears to be stillborn. Over the bed, hangs the picture of an old woman with a grimace of shock or sorrow. The painting is an image of maternal suffering, which is inextricable from maternal love—the anguish of labor tied to the pain of being female.

Frida's life is almost evenly divided into two eras: the twenty-five years she spent in her mother's loving clutches, and the twenty-two that she lived on, grieving their separation.

William H. Johnson

(1901 – 1970)

Son of Alice Smoot Johnson

🌿

ALICE SMOOT JOHNSON WAS A MOTHER of five who cleaned, cooked, and ironed for white families in her hometown of Florence, South Carolina in order to support her own family. Domestic work was one of the only avenues open to her, and she was the sole breadwinner after her hard-working husband was injured in an accident. Alice was of mixed African-American and Native American descent, and she, her husband, and their four youngest children were all relatively dark- skinned, which made her pale, oldest son, William, the striking exception. There was a ten year age gap between William and his next closest sibling, and people speculated that William's father had been one of Alice's white employers. Whoever he was, he did nothing to support his son.

William didn't have much formal education; he dropped out of high school and worked in the fields to help his mother take care of the family. But he taught himself to draw by copying comic strips from the newspaper, and he practiced diligently enough that his sketching in dirt caught a teacher's attention. This teacher gave him art supplies and encouraged his ambition. Eager for a career, William left South Carolina in 1919, for New York, where he was admitted to the prestigious National Academy of Design. By the time that he returned to South Carolina, a decade later, with his Danish wife, the potter Holcha Krake, he was a citizen of the world who had lived in Paris, North Africa, and Scandinavia. And he was very proud to show Alice his paintings.

William didn't stay long in America, and particularly not in the South, where intermarriage was a crime—"miscegenation." The couple lived abroad until World War II began. Holcha died in 1943, and, grief-stricken, William again visited his mother. This portrait of Alice was one of his last paintings. His life was long, but his career was relatively short. Grief for Holcha exacerbated a pre-existing mental illness, and in 1946, William was admitted to a hospital for the insane, where he spent the rest of his life. He never again picked up a paintbrush. He left, however, a significant body of work in various genres, of which the most successful was what he called, self-deprecatingly, a "primitive" style.

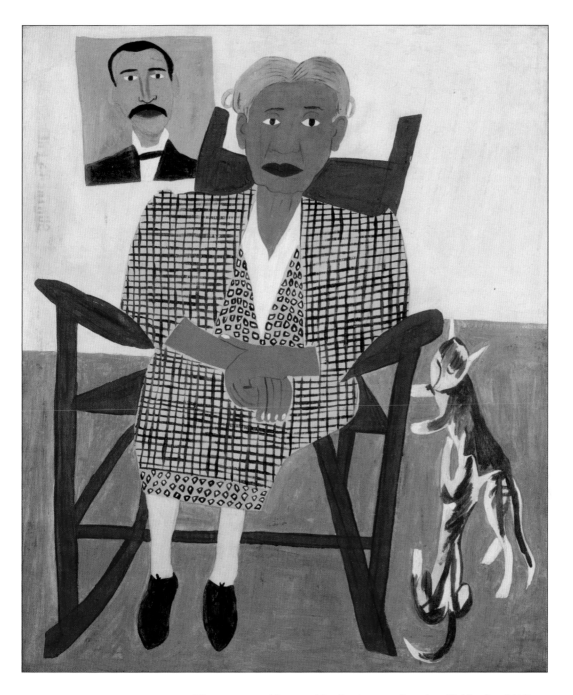

This painting, *Mom and Dad,* was completed in 1944, when William returned home to South Carolina to visit his widowed mother.

The Artist's Mother ℬ 113

Alberto Giacometti

(1901 – 1966)

Son of Annetta Stampa

ꓥ

ANNETTA STAMPA WAS THE MOTHER of two artist sons, each of whom achieved greatness in his field. Alberto, her eldest, became one of the most important painters and sculptors of the twentieth century. Diego, who was one year younger, would also become a renowned sculptor and graphic designer. Annetta was, herself, a statuesque figure, tall and handsome; an excellent cook; and a savvy business manager. She had a sharp sense of humor and a fondness for intellectual debates. There was rarely any discord in her well-run household. Alberto Giacometti's portrait of the old Annetta is one of his most famous works. Despite her age, she comes across as robust and contained, a self-possessed figure at the center of a radiantly colored room.

By the time Annetta sat for this portrait, in 1950, at eighty, she was an expert model. She had been posing for artists since 1900, when she married Giovanni Giacometti, a well-respected painter from Stampa, their hometown in Switzerland. Alberto was precocious, and a 1913 portrait of Annetta sewing was among his earliest works. In the course of half a century, she posed for him countless times, and his approach became more ambitious with each new canvas.

Giacometti always thought of Annetta as his first muse, and liked to recall an image that still haunted him as an old man. His mother was wearing a long black dress that, he said, "troubled me by its mystery," The hours, if not years, that he spent recasting her image in pencil, oil, and clay or bronze were, in part, a meditation on that that mystery.

Annetta lived a long and full life, and remained her sons' most faithful fan. She died in 1964, at ninety-four. Alberto outlived her by two years. In her nineties, Annetta and Alberto, now recognized as a great master, were photographed in his studio. He towers over her as she grins proudly at his sculptures. The affection and pride were mutual. Whenever they were separated, they exchanged vivid letters. She was part of his life even from afar.

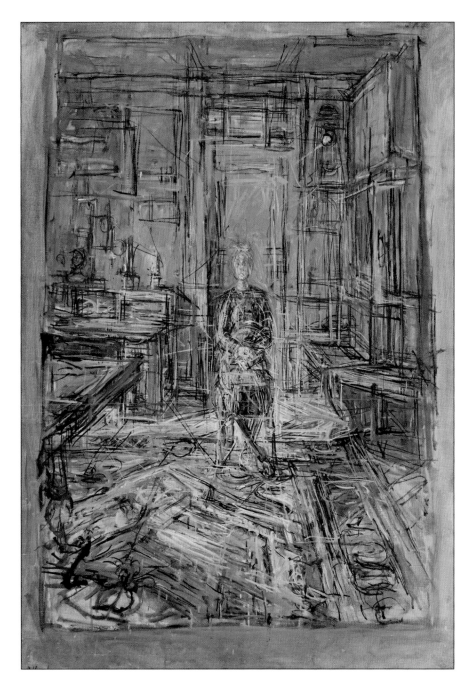

Alberto Giacometti's *The Artist's Mother*, 1950.

Paul Brooks Davis

(1938 –)

Son of Mary Susan Brookhart Davis

❧

In 1968, the noted illustrator Paul Davis was commissioned to design the cover for an LP of songs from the 1930s. *Bonnie & Clyde*, directed by Arthur Penn, a landmark in American cinema, had come out the previous year. Its popularity, especially with the rebellious, younger generation, had helped to revive an interest in the history, culture, and styles of the Depression era. While the album wasn't officially tied to the movie, the record producers hoped to ride on the film's coattails. They couldn't use an image of the stars, Faye Dunaway and Warren Beatty, but Paul immediately thought of another model: his own mother.

Mary Davis had been born in 1909, in Kansas. She and Bonnie Parker were both daughters of the Great Plains who shared a birth year and a haircut. The photo on which Paul had based this image was taken by Mary's sister in the late 1920s. The subject was a would-be flapper who had just dared to get her first "bob." She would have been in her late teens, and Paul recalled hearing stories of how shocking his mother's new look was—both to Mary herself, who sat in the beautician's chair watching her flowing tresses fall to the floor, and to her old-fashioned parents. Mary was one of nine children—and eight girls. Her father, Homer Ulysses Brookhart, was the owner of a local paper, the *Bunker Hill Advertiser,* and his progeny all took turns working at the office, although Mary outlasted the others. Even after Homer sold the *Advertiser*, she stayed on as its editor.

The Brookhart and Davis houses were both full of books. Mary and Howard, Paul's father, met at an Arkansas college. Howard, a Methodist preacher, was asked to move from congregation to congregation in Oklahoma, often with his young family, and he told Mary that he dreamed of the day that they'd settle down in a big house that could hold their library. Mary laughed—no house smaller than Versailles would be big enough, she said.

According to Paul, Mary was instrumental in launching his career. "She drew well, and taught me a lot of things," he says. His mother would clip daily drawing instructions from the newspaper and paste them into a scrapbook, working through the new lessons with him. Although she believed in and encouraged his talents, she never let success go to his head. In 1977, he was honored with an exhibition at the Pompidou Center, in Paris. Among the illustrious guests were the presidents of France, Morocco, Belgium, and Congo. After the grand opening party, Mary had Paul took a stroll through the streets of Montmartre, where they passed a number of sidewalk artists plying their trade to the tourists. Mary turned to Paul and asked him, "Why is it you have a show in a museum and these people are out drawing in the street?"

Paul Davis's 1968 painting of his mother as Bonnie Parker, of Bonnie and Clyde.

Andy Warhol

(1928 – 1987)

Son of Julia Zavacky Warhola

❧

A NDY WARHOL, A COMMERCIAL ARTIST and illustrator from Pittsburgh, became as much of a household name as the Campbell soup can in his iconic painting, one of many subversive works from the 1960s that launched the Pop Art movement. In her own more modest way, his mother Julia also became famous. She lived with her adult son for twenty years, the formative (and most sensational) period of his career, when he presided over a louche coterie of stars, artists, groupies, socialites, waifs, and underground characters at "The Factory." Julia starred in a Warhol film (*Mrs. Warhol*), and won awards for her calligraphy. She was musical and artistic—she sang folk songs from her native Slovakia, drew and embroidered charmingly (her favorite subjects were angels and cats), and made her own version of pop art: handmade paper flowers arranged in tin cans. She and Andy were inseparable, and they sometimes collaborated on his illustrations. He never married (his sexual orientation was ambiguous), and he probably never had a closer friend, male or female, than his mother.

Julia Warhola (Andy dropped the "a" from his surname) was born in a Carpathian farming village at the junction of four frontiers: between Austria, Hungary, Russia, and Poland. She married Andy's father, Andrew, at sixteen, and after the birth of their two older sons, he left for America, to seek his fortune. But when the village was decimated by influenza, Julia borrowed $160 from her parish priest and followed her husband. They settled in Pittsburgh, where Andy was born in 1928.

Warhol's father, a coal miner and a construction worker, died when Andy was thirteen. In third grade, he was diagnosed with St. Vitus's Dance, a serious complication of rheumatic fever. It affected his nervous system—he had involuntary twitches—and his pigmentation,

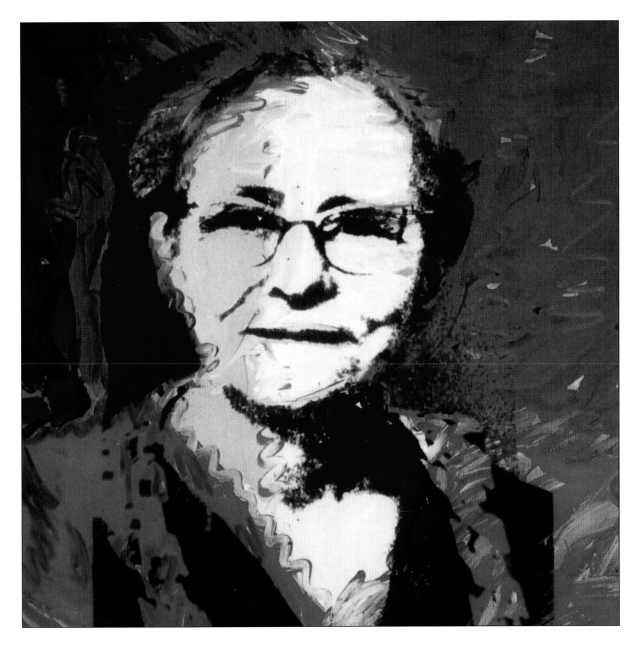

Andy Warhol's *Julia Warhola*, 1974.

The Artist's Mother 119

which was chalk-like and blotchy. His experience with hospitals turned him into a hypochondriac, although it also made him phobic about doctors. A misfit and an outcast among other children (his strange appearance, frailty, effete manners, deadpan affect, and, probably, also his budding genius set him apart.) So he was often alone, at home, with Julia, drawing in bed and collecting pictures of movie stars. She coddled him, and when he moved to New York, in 1949, at twenty-one, she followed, two years later, and continued to coddle him. They moved in together.

Warhol completed this painting, a combination of synthetic paint and silkscreen, in 1974, two years after Julia died.

The Artist's Mother

Important Dates

for Artists and Their Mothers

1471: Albrecht Dürer, the leading Northern Renaissance painter, is born in Nuremburg.

1490: Barbara Holper Dürer models for her son, Albrecht Dürer. Barbara is thirty-nine, Albrecht nineteen.

1514: Albrecht Dürer has his mother model again, this time for a drawing, which he completes only weeks before her death.

1528: Albrecht Dürer dies, having changed medieval ideas about painting and fomented an artistic revolution.

1532: Sofonisba Anguissola is born in Lombardy.

1557: Sofonisba Anguissola paints her mother, Bianca Ponzone, as she imagines she would have looked during her youth. Because Bianca died when Sofonisba was a small child, this painting is executed from her imagination.

1575: Guido Reni is born in Bologna.

c. 1600: Ginevra de'Pozzi, Guido Reni's mother, poses for her son. She is the only woman he will tolerate in his house.

1606: Rembrandt van Rijn is born in Leiden, The Netherlands.

1625: Sofonisba Anguissola dies after a long, international career that took her to the courts of Spain.

1629–1631:	Rembrandt has his mother, Cornelia, pose for him and his friends in various biblical costumes. A whole series of oil paintings of Cornelia are completed during these years. Cornelia is in her early sixties, Rembrandt in his late twenties.
1641:	Guido Reni dies, leaving behind a large body of commissioned religious work.
1659:	Hyacinthe Rigaud is born in Perpignan, a Catalan village.
1669:	Rembrandt van Rijn dies.
1695:	Maria Serra Rigaud poses for her son, Hyacinthe, in an unusual double portrait in which she faces herself.
1743:	Hyacinthe Rigaud dies in Paris, where he was the chief court painter for King Louis XIV.
1755:	Elisabeth-Louise Vigée-Lebrun is born in Paris.
1776:	John Constable is born in Suffolk, England.
1787:	Elisabeth-Louise Vigée-Lebrun paints her famous series of Marie Antoinette and her children.
1789:	Elisabeth-Louise Vigée-Lebrun completes her famous painting of herself and her daughter, Julie.
1796:	Camille Corot is born in Paris.
c. 1810:	John Constable paints a portrait of his mother, Ann, in which he depicts her as a young woman.
1810:	Christen Købke is born in Copenhagen.
1828:	Dante Gabriel Rossetti is born in London.
1833:	Marie-Françoise Oberson Corot, the famous hatmaker, models for her son, Camille.
1834:	James Whistler is born in Lowell, Massachusetts.
1839:	Christen Købke paints his mother, Cecilie Margrete.
1839:	Paul Cézanne is born in Aix-en-Provence.
1841:	Berthe Morisot is born in Bourges, France.

1844: Mary Cassatt is born in Allegheny City, Pennsylvania.

1848: Christen Købke dies at age thirty-eight.

1848: Paul Gauguin is born in Paris to a French father and a half-Peruvian
 mother.

1849: Dante Gabriel Rossetti has his mother, Frances Polidori, and his sister,
 Christina, pose as St. Anne and the Virgin Mary, respectively, in *The Girl-
 hood of Mary Virgin.*

1853: Vincent van Gogh is born in Zundert, The Netherlands.

1856: Marie Louise Catherine Breslau is born in Munich.

1859: Henry Ossawa Tanner is born in Pittsburgh, Pennsylvania.

1859: Georges Seurat is born in Paris.

1861: Jacques-Émile Blanche is born in Paris.

1864: Henri de Toulouse-Lautrec is born in his family's estate in Albi, France.

1869: Paul Cézanne paints *Tannhauser Overture*, a portrait of his sister, Marie,
 and his mother, Elizabeth.

1869: Philip Alexius de László is born in Budapest.

1870: Berthe Morisot enters her famously problematic portrait of her
 mother and sister in the Salon.

1871: James Whistler debuts his painting *Arrangement in Grey and Black,* which
 will become more commonly known as "The Mother."

1875: Camille Corot dies, after a long and very influential career as one of
 Frances' most successful living painters.

1878: Mary Cassatt paints *Reading Le Figaro,* or *Portrait of a Lady,* the most
 famous of her portraits of her mother, Katherine Kelso Johnson
 Cassatt.

1879: Charles Camoin is born in Marseilles.

1881: Fernand Léger is born in Basse-Normandie, France.

1881: Pablo Picasso is born in Malaga, Spain.

1882: Dante Gabriel Rossetti dies in Kent after a long illness.

1882: Adèle, the Comtesse de Toulouse-Lautrec, sits for one of the many portraits her son paints of her.

1882: Umberto Boccioni is born in Reggio Calabria, Italy.

1882: George Bellows is born in Columbus, Ohio.

1882–3: Georges Seurat paints a series of portraits of his mother, Ernestine, in black and white.

1885: Louise Catharine Breslau paints what is perhaps her most famous portrait, *Intimacy*, of her sister, Bernardina, and her mother, Katharina.

1888: Vincent van Gogh paints a famous portrait of his mother.

1888: Giorgio de Chirico is born in Volos, Greece.

1890: Jacques-Émile Blanche paints his mother, Rose.

1890: Vincent van Gogh shoots himself in France at age thirty-seven after suffering years of severe mental illness.

1891: Georges Seurat dies in his studio in Paris at age thirty-one of diptheria.

1891: Mark Gertler is born in London's East End.

1891: Archibald Motley is born in New Orleans, Louisiana.

1894: Paul Gauguin, who is living in French Polynesia, paints a picture of his mother for himself. He bases the portrait on a black-and-white photo taken of her when she was fourteen.

1895: Berthe Morisot dies after a prolific career, having helped found the Impressionist movement.

1896: Pablo Picasso paints his first formal portrait of his mother, María. He is fifteen years old.

1897: Henry Ossawa Tanner paints his *Portrait of the Artist's Mother*, a mimic of James Whistler's famous *Arrangement in Grey and Black*.

1901: Henri de Toulouse-Lautrec dies after a short life full of medical difficulties. His mother, Adèle, begins the crusade to establish his legacy as an artist.

1901: William H. Johnson is born in Florence, South Carolina.

1901: Alberto Giacometti is born in Stampa, Switzerland.

c. 1902: Arshile Gorky is born (as Manoug Adoian) near Van in Armenia.

1903: James Whistler dies in London.

1903: Paul Gauguin dies in the Marquesas Islands of French Polynesia.

1905: Charles Camoin, who is very close to his mother, paints one of his many portraits of her.

1906: Paul Cézanne dies after a long and influential career.

1907: Frida Kahlo is born in Mexico City.

1909: Fernand Léger paints his famous "Tubist" portrait of his mother. He calls the painting *The Seamstress*.

1911: Mark Gertler has his mother, Golda, sit for a traditional portrait, which will become one of the most beloved works by this modernist painter.

1912: Umberto Boccioni paints *Materia,* which is only one of many portraits he painted of his mother but which has become perhaps his most famous work.

1913: Mark Gertler paints his second cubist portrait of his mother.

1914: Philip Alexius de László paints a portrait of his mother, Johanna Laub, a few months before she dies. He keeps the portrait in his studio for the rest of his life.

1916: Umberto Boccioni is trampled to death during a cavalry drill. He is thirty-four.

1919: Giorgio de Chirico paints a double portrait of himself and his mother.

1919: Shushan Adoian, Arshile Gorky's mother, dies of starvation in her son's arms during the Armenian Genocide.

1921: George Bellows paints his mother, Anna.

1923: Pablo Picasso paints his second portrait of his mother, María.

1925: George Bellows, one of the foremost Ashcan School painters, dies of a ruptured appendix at forty-two.

1925: Arshile Gorky begins the first version of the double portrait of himself and his mother, which he will paint and repaint on at least two different canvases over the next fifteen years.

1925: Frida Kahlo, who is eighteen, survives a bus crash that leaves her with numerous severe injuries, and which inspires her to devote herself to painting fulltime.

1926: Mary Cassatt dies. Her biographers will remember her as "a painter of mothers and children."

1927: Louise Catherine Breslau dies after a long illness.

1928: Andy Warhol is born in Pittsburgh, Pennsylvania, to Slovakian immigrants.

1929: Archibald Motley paints his mother, Mary, in his Paris apartment.

1937: Henry Ossawa Tanner dies in Paris, where he had been living for most of his adult life.

1936: Frida Kahlo paints *My Grandparents, My Parents, and I*, four years after her mother's death.

1937: Philip de László dies after a long career as Europe's most eminent portraitist.

1938: Paul Brooks Davis is born.

1939: Mark Gertler commits suicide after the loss of his mother, the suicide of his lover, and years of severe depression.

1942: Jacques-Émile Blanche dies after a long life that included friendships with Èdouard Manet, Edgar Degas, Marcel Proust, Aubrey Beardsley, John Singer Sargent, James Whistler, Oscar Wilde, and Virginia Woolf.

1944: William H. Johnson paints a portrait of his mother. It is one of the last paintings he ever finishes.

1948: After struggling with depression for much of his life, Arshile Gorky hangs himself in his Connecticut house.

The Artist's Mother

1950: Alberto Giacometti paints what will become the most famous of his many depictions of his mother, Annetta Stampa.

1954: Frida Kahlo dies after decades of medical problems and severe pain.

1955: Fernand Léger dies at his home in Glf-sur-Yvette.

1965: Charles Camoin dies at eighty-six, a fomenter of the Fauvist movement.

1966: Alberto Giacometti dies in Switzerland of heart disease.

1968: Paul Davis uses a photo of his mother as a model for the cover image of a Bonnie and Clyde-era song compilation.

1970: William H. Johnson dies in a mental hospital, where he has been living for more than twenty years.

1973: Pablo Picasso dies in France.

1974: Andy Warhol completes his portrait of his mother, Julia Warhola, two years after she died.

1978: Giorgio de Chirico, a founder of the Surrealist movement, dies at ninety.

1981: Archibald Motley dies at ninety in Chicago.

1987: Andy Warhol dies at fifty-eight after a gallbladder surgery.

Notes on the Text

page

12 *a show of craft that outdid everything his predecessors in German painting had accomplished* Anja Eichler, *Albrecht Dürer: 1471–1528*, (Bonn: Tandem Verlag GmbH, 2007), 13.

12 *at least eighteen times* Eichler, 10.

14 *were a symbol of sin* Eichler, 106.

22 *offering respect to a subject* Julia Lloyd Williams, *Rembrandt's Women*, (Munich: Prestel-Verlag, 2001), 66.

22 *decidedly middle-class families* Jakob Rosenburg, *Rembrandt: Life and Works*, (Ithaca: Cornell University Press, 1980), 9.

23 *"had no desire or inclination whatsoever…"* Lloyd Williams, 67.

26 *"best known for the pictures…"* Edmund Robert Otto von Mach, *The Art of Painting in the Nineteenth Century*, (London: Ginn and Company, 1908).

26 *managed to lose more than one million francs* Elisabeth Vigée-Lebrun, *Memoirs of Madame Vigée-Lebrun,* translated by Lionel Strachey, (New York: Doubleday, Page & Company, 1903), Chapter 2.

28 *"These pleasures of gratified vanity…"* Vigée-Lebrun, Chapter 2.

28 *until moonrise* Vigée-Lebrun, Chapter 5.

28 *"She was charming in every respect…"* Vigée-Lebrun, Chapter 9.

30 *"Pray be very Careful…"* Ian Fleming-Williams, *Constable and His Drawings*, (London: Philip Wilson Publishers Unlimited, 1990), 150.

30 *"one bright genius…"* Fleming-Williams, 107.

32 *"Mme. Corot rivaled in taste…"* Gary Tinterow, Michael Pantazzi and Vincent Pomarède, *Corot,* (New York: The Metropolitan Museum of Art, 1996), 6.

32 *"trembled when his father spoke"* Tinterow, 8.

35 *very awkward* Tinterow, 8.

35 *would ask permission before dining out* Tinterow, 148.

36 *"a conspiracy of silent affection"* John Russell, "Art Review: Golden Days for Painting in Denmark," *New York Times:* 14 May 1999.

38 *"I always had a passion for intellect…"* Alicia Craig Faxon, *Dante Gabriel Rossetti,* (New York: Abbeville Press, 1989), 32.

38 *the rejection of the corset* Faxon, 17.

40 *"There was our father…"* Faxon, 81–82.

40 *saved all his reviews* Faxon, 56.

42 *"loved her…"* Philip Callow, *Lost Earth: A Life of Paul Cézanne,* (London: Allison & Busby, 1995), 20.

42 *extremely imaginative* Callow, 20.

44 *"That was where my misfortunes began…"* Margaret Shennan, *Berthe Morisot: The First Lady of Impressionism,* (Somerset: Sutton Publishing Limited, 1996), 95–96.

46 *"kept telling me she would rather…"* Shennan, 96.

46 *a progressive mother* Shennan, 15.

46 *"the picture of youth and happiness"* Shennan, 17.

46 *bad for a woman's health* Shennan, 32.

47 *six hundred francs* Anne Higonnet, *Berthe Morisot's Images of Women,* (Cambridge: Harvard University Press, 1992), 5.

48 *"a most delightful old lady…"* Margaret F. MacDonald, *Whistler's Mother: An American Icon,* (Hampshire: Lund Humphries, 2003), 13.

48 *"Oh Jemie…"* MacDonald, 18.

50 *"you my Mother…"* MacDonald, 29.

50 *"posting for the all over"* Sarah Walden, *Whistler and His Mother: An Unexpected Relationship*, (Lincoln: University of Nebraska Press, 2003), 81.

50 *negotiated James's first commission* MacDonald, 20.

50 *"I refused all invitations…"* MacDonald, 31.

51 *"the dignified feel of old ladyhood"* MacDonald, 123.

51 *"Now that is what it is…"* MacDonald, 123.

51 *"Old Age Must Come"* MacDonald, 131.

51 *"…the Holiest Thing Alive"* MacDonald, 131.

51 *"Home Is Where the Computer Is"* MacDonald, 134.

52 *"anyone who had the priilege"* Nancy Mowll Mathews, *Mary Cassatt: A Life*, (New York: Villiard Books, 1994), 235.

52 *"Mrs. Cassatt had the most alert mind…"* Mathews, 235–236.

52 *"Mary is at work again…"* Mathews, 200.

54 *an excellent match* Mathews, 5.

54 *she wanted to be an artist* Mathews, 15.

54 *enlightened, modern mindset* Mathews, 18.

54 *never strayed far* Mathews, 78.

55 *not sentimental enough* Mathews, 78.

55 *others hailed her realism* Mathews, 80.

55 *"After all a woman who is not married…"* Mathews, 200.

56 *Every afternoon…* Jula Frey, *Toulouse-Lautrec: A Life*, (London: Weidenfeld and Nicolson, 1994), 1.

56 *"Maman" to her face* Frey, 6.

56 *would fall into a state of despair* Frey, 19.

56 *"I had no idea…"* Frey, 54.

56 *long, elaborate letters* Frey, 6.

59 *of their fourteen children* Frey, 71.

59 *"fruit of the violent passion…"* Frey, 12.

59 *layers of bulky undergarments* Frey, 2.

59 *"rough sketches"* Frey, 493.

64 *offering a response* Dewey F. Mosby, *Across Continents and Cultures: The Art and Life of Henry Ossawa Tanner*, (Kansas City: The Nelson-Atkins Museum of Art, 1995), 44.

64 *born in slavery* Steven Otfinoski, *African Americans in the Visual Arts*, (New York: Facts on File, Inc. 2003), 196.

64 *kept for his private collection* Mosby, 42.

67 *"I was extremely timid…"* Marcus C. Bruce, *Henry Ossawa Tanner*, (New York: The Crossroad Publishing Company, 2002).

67 *in the 1800 census* Marcia M. Mathews, *Henry Ossawa Tanner: American Artist*, (Chicago: University of Chicago Press, 1969), 9.

72 *patient, submissive wife* Herbert, Robert L. *Georges Seurat: 1859–1891*. New York: The Metropolitan Museum of Art. 1991), 11.

72 *size suggests the outsized place* Herbert, 51.

74 *chubby, cheerful, and energetic* Derek Fell, *Van Gogh's Women: His Love Affairs and a Journey into Madness,* (New York: Da Capo Press), 2004, 10.

77 *an agent of art* Fell, 169.

77 *free room and board* Fell, 173.

78 *what critics did not* Fell, 316.

78 *talked late into the night* Fell, 317.

86 *"the world's magnificence…"* Mark Stevens, "Futurist Tense: A Guggenheim exhibit shows how Umberto Boccioni's portrait of his mother turned Cubism on its head—and irked the French," (*New York* magazine, February 23, 2004).

90 *"the very best…"* *A Brush with Grandeur: Philip Alexius de László (1869–1937)*, Essays by Suzanne Barley, Gábor Bellák, Christopher Lloyd, Richard Ormond, Christopher Wood, (London: Paul Holberton Publishing, 2004), 130.

90 *"In my studio there stands…"* *A Brush with Grandeur*, 130.

90 *his father as a distant tyrant* *A Brush with Grandeur*, 96.

90 *"I am so grateful…"* *A Brush with Grandeur,* 130.

92 *had a private theory* Margaret Crosland, *The Enigma of Giorgio de Chirico,* (London: Peter Owen, 1999), 18.

92 *famous love of jewelry* Crosland, 17–18.

92 *Raissa recalled escaping* Crosland, 98.

92 *always looking fro a woman* Crosland, 97.

92 *how to dress for dinner* Crosland, 43.

92 *Two de Chirico men* Crosland, 15.

92 *part Turkish* Crosland, 19.

96 *cheerful, stable, and lovable* Mary Mathews Gedo, *Picasso: Art as Autobiography,* (Chicago: University of Chicago Press, 1980), 10.

96 *"an angel and a devil…"* Gedo, 11.

100 *framed the canvas* Jontyle Theresa Robinson and Wendy Greenhouse. *The Art of Archibald J. Motley, Jr.,* (Chicago: The Chicago Historical Society, 1991), 5.

100 *few racial tensions* Robinson, 2.

100 *"a pygmy from…"* Robinson, 1.

103 *semi-pro career* Robinson, 3.

103 *couldn't get a job* Otfinoski, 139.

103 *credit Mary with helping to cultivate his eye* Amy M. Mooney, *Archibald J. Motley Jr.,* (San Francisco: Pomegranate Communications, Inc., 2004), 19.

103 *"This material is obsolete…"* Robinson, 6.

103 *"I painted a beautiful picture…"* "Archibald Motley Oral History Interview," conducted by Dennis Barrie for the Archives of American Art, 1978.

112 *hard-working husband* Carol Sears Botsch, "William H. Johnson," The University of South Carolina-Aiken, last updated March 16, 1999, http://www.usca.edu/aasc/johnson.htm (November 11, 2008).

112 *all relatively dark-skinned* Steve Turner and Victoria Dailey, *William H. Johnson: Truth Be Told,* (Los Angeles: Seven Arts Publishing, 1998), 18.

112 *"primitive" style* Botsch.

114 *fondness for intellectual debates* James Lord, *Giacometti: A Biography,* (New York: Farrar Straus Giroux, 1985), 5.

114 *rarely any discord* Lord, 12.

114 *Annetta sewing* Laurie Wilson, *Alberto Giacometti: Myth, Magic, and the Man,* (New Haven: Yale University Press, 2003), 31.

114 *"troubled me by its mystery"* Lord, 7.

116 *"She drew well…"* Paul Davis interview by Connie Rotundo, November 7, 2008, New York, New York.

Sources

A Brush with Grandeur: Philip Alexius de László (1869 – 1937). Essays by Suzanne Barley, Gábor Bellák, Christopher Lloyd, Richard Ormond, Christopher Wood. London: Paul Holberton Publishing. 2004.

Botsch, Carol Sears. "William H. Johnson." The University of South Carolina-Aiken, last updated March 16, 1999. http://www.usca.edu/aasc/johnson.htm (November 11, 2008).

Callow, Philip. *Lost Earth: A Life of Paul Cézanne*. London: Allison & Busby. 1995.

Coen, Ester. *Umberto Boccioni*. New York: The Metropolitan Museum of Art. 1988.

Crosland, Margaret. *The Enigma of Giorgio de Chirico*. London: Peter Owen. 1999.

Davis, Paul. Interview by Connie Rotundo. November 7, 2008. New York, New York.

Eichler, Anja. *Albrecht Dürer: 1471-1528*. Bonn: Tandem Verlag GmbH. 2007.

Faxon, Alicia Craig. *Dante Gabriel Rossetti*. New York: Abbeville Press. 1989.

Fell, Derek. *Van Gogh's Women: His Love Affairs and a Journey into Madness*. New York: Da Capo Press. 2004.

Fleming-Williams, Ian. *Constable and His Drawings*. London: Philip Wilson Publishers Unlimited. 1990.

Frey, Julia. *Toulouse-Lautrec: A Life*. London: Weidenfeld and Nicolson. 1994.

Gedo, Mary Mathews. *Picasso: Art as Autobiography*. Chicago: University of Chicago Press. 1980.

Herbert, Robert L. *Georges Seurat: 1859-1891*. New York: The Metropolitan Museum of Art. 1991.

Herrera, Hayden. *Frida: A Biography of Frida Kahlo*. New York: Harper & Row. 1983.

Higonnet, Anne. *Berthe Morisot's Images of Women*. Cambridge: Harvard University Press. 1992.

Holzhey, Magdalena. *Giorgio de Chirico: 1888 – 1978: The Modern Myth*. Köln: Taschen. 2005.

Kahlo, Frida. *The Diary of Frida Kahlo: An Intimate Self-Portrait*. ed. Sarah. M. Lowe. New York: Harry N. Abrams, Inc. 1995.

Lloyd Williams, Julia. *Rembrandt's Women*. Munich: Prestel-Verlag. 2001.

Lord, James. *Giacometti: A Biography*. New York: Farrar Straus Giroux. 1985.

MacDonald, Margaret F. *Whistler's Mother: An American Icon*. Hampshire: Lund Humphries. 2003.

Mancoff, Debra N. *Mary Cassatt: Reflections of Women's Lives*. New York: Atewart, Tabori & Chang. 1998.

Marsh, Jan. *Dante Gabriel Rossetti: Painter and Poet*. London: Weidenfeld & Nicolson. 1999.

Mathews, Marcia M. *Henry Ossawa Tanner: American Artist*. Chicago: University of Chicago Press. 1969.

Mathews, Nancy Mowll. *Mary Cassatt: A Life*. New York: Villiard Books. 1994.

Matossian, Nouritza. *Black Angel: A Life of Arshile Gorky*. London: Chatto & Windus. 1998.

McMullen, Roy. *Degas: His Life, Times, and Work*. Boston: Houghton Mifflin. 1984.

Mooney, Amy M. *Archibald J. Motley Jr*. San Francisco: Pomegranate Communications, Inc. 2004.

Mosby, Dewey F. *Across Continents and Cultures: The Art and Life of Henry Ossawa Tanner*. Kansas City: The Nelson-Atkins Museum of Art. 1995.

Motley, Archibald J. Interview by Dennis Barrie. *The Archives of American Art*, 1978.

Otfinoski, Steven. *African Americans in the Visual Arts*. New York: Facts on File, Inc. 2003.

Robinson, Jontyle Theresa and Wendy Greenhouse. *The Art of Archibald J. Motley, Jr*. Chicago: The Chicago Historical Society. 1991.

Rosenberg, Jakob. *Rembrandt: Life and Works*. Ithaca: Cornell University Press. 1980.

Schwartz, Sanford. *Christen Købke*. New York: Timken Publishers. 1992.

Shennan, Margaret. *Berthe Morisot: The First Lady of Impressionism*. Somerset: Sutton Publishing Limited. 1996.

Sheriff, Mary d. *The Exceptional Woman: Elisabeth Vigée-Lebrun and the Cultural Politics of Art*. Chicago: University of Chicago Press. 1997.

Sweetman, David. *The Love of Many Things: A Life of Vincent van Gogh*. London: Hodder and Stoughton. 1990.

Turner, Steve and Victoria Dailey. *William H. Johnson: Truth Be Told*. Los Angeles: Seven Arts Publishing. 1998.

van Gogh, Vincent. *Letters of Vincent van Gogh to His Brother and Others, 1872-1890*. Abridged by Elfreda Powell. London: Constable & Robinson Ltd. 2003.

Vigée-Lebrun, Elisabeth. *Memoirs of Madame Vigée-Lebrun*. Translated by Lionel Strachey. New York: Doubleday, Page & Company, 1903.

Vogelaar, Christiaan and Gerbrand Korevaar. *Rembrandt's Mother: Myth and Reality*. Zwolle: Waanders Publishers. 2005.

von Mach, Edmund Robert Otto. *The Art of Painting in the Nineteenth Century*. London: Ginn and Company. 1908.

Walden, Sarah. *Whistler and His Mother: An Unexpected Relationship*. Lincoln: University of Nebraska Press. 2003.

Wilson, Laurie. *Alberto Giacometti: Myth, Magic, and the Man*. New Haven: Yale University Press. 2003.

Credits

This page constitutes a continuation of the copyright page.

Albrecht Durer, *Portrait of Barbara Holper, the Artist's Mother,* 1514. Charcoal. Kupferstichkabinett, Staatliche Museen zu Berlin, Berlin, Germany.

Sofonisba Anguissola, *Portrait of a Young Woman,* 1557. Oil on canvas, 98 x 75 cm. Location: Gemaeldegalerie, Staatliche Museen zu Berlin, Berlin, Germany. Courtesy Bildarchiv Preussischer Kulturbesitz/Art Resource, NY.

Guido Reni, *The Artist's Mother,* 1600. Location: Pinacoteca Nazionale, Bologna, Italy. Courtesy Scala/Art Resource, NY.

Rembrandt van Rijn, *The Artist's Mother as the Prophetess Anna,* 1640, Courtesy of Stichting Het Rijksmuseum, Amsterdam, Netherlands.

Hyacinthe Rigaud, *Mme. Rigaud, the Painter's Mother, a Double-Portrait,* 1695. Location: Louvre, Paris, France. Courtesy Erich Lessing/Art Reource, NY.

Louise Elizabeth Vigee-LeBrun, *Madame Vigee-LeBrun and Her Daughter,* 1789. Oil on wood. Location: Louvre, Paris, France. Courtesy Réunion des Musées Nationaux / Art Resource, NY.

John Constable, *Anne Constable, The Artist's Mother,* 1800–05. Oil on canvas, 76.5 x 63.9 cm. Location: Tate Gallery, London, Great Britain. Tate, London/Art Resource, NY

Jean-Baptiste-Camille Corot, *Madame Corot, Mother of the Painter.* 1845. Scottish National Gallery of Modern Art, Edinburgh, Scotland, Great Britain. Courtesy Erich Lessing/Art Resource, NY.

Dante Gabriel Rossetti, *The Girlhood of Mary Virgin,* 1848–49. Oil on canvas, 83.2 x 65.4 cm. Location: Tate Gallery, London, Great Britain. Courtesy Tate, London/Art Resource, NY.

Paul Cezanne. *Tannhauser Overture*, 1869. Canvas, 75 x 92 cm. Location: Hermitage, St. Petersburg, Russia. Courtesy Erich Lessing/Art Resource, NY.

James Abbott McNeill Whistler, *Arrangement in Grey and Black No. 1, or the Artist's Mother (Anna Mathilda McNeill, 1804–81)*. 1871. Oil on canvas, 144.3 x 162.5 cm. Location: Musee d'Orsay, Paris, France.

Edouard Manet, *The Swallows: The Painter's Mother and His Wife in Berck-sur-Mer, Summer 1873*. Location: Foundation E.G. Buehrle, Zurich, Switzerland. Courtesy of Erich Lessing/Art Resource, NY.

Henri de Toulouse-Lautrec, *Comtesse Adele-Zoe de Toulouse-Lautrec, the Artist's Mother*, 1882. Location: Musee Toulouse-Lautrec, Albi, France. Courtesy Erich Lessing/Art Resource, NY.

Henri de Toulouse-Lautrec, *The Countess Alphonse de Toulouse-Lautrec, the Painter's Mother, in the Drawing Room at the Chateau de Malrome*. 1886 or 87. Location: Musee Toulouse-Lautrec, Albi, France. Courtesy Erich Lessing/Art Resource, NY.

Marie Louise Catherine Breslau, *Chez Soi, or Intimite (Catharina and Bernardina Breslau, mother and sister of the artist)*, 1885. Oil on canvas. Location: Musee d'Orsay, Paris, France. Courtesy Réunion des Musées Nationaux / Art Resource, NY.

Jacques Emile Blanche, *The Artist's Mother*, 1890. Location: Musee des Beaux-Arts, Rouen, France. Courtesy Giraudon/Art Resource, NY.

Henry Ossawa Tanner, *Portrait of the Artist's Mother*, 1897. Oil on canvas. Location: Philadelphia Museum of Art, Philadelphia, Pennsylvania, USA. Courtesy The Philadelphia Museum of Art / Art Resource, NY.

Charles Camoin, *The Artist's Mother*, 1905. Oil on canvas. 65 x 46. Courtesy Banque d'Images, ADAGP / Art Resource, NY. © 2008 Artists Rights Society (ARS), New York / ADAGP, Paris.

Fernand Leger, *The Seamstress (The Artist's Mother)*, 1909–1910. Oil on canvas. 73 x 54 cm. Location: Musee National d'Art Moderne, Centre Georges Pompidou, Paris, France. © 2008 Artists Rights Society (ARS), New York, ADAGP, Paris. Digital image © CNAC/MNAM/Dist. Réunion des Musées Nationaux/Art Resource, NY

Mark Gertler, *The Artist's Mother*, 1911. Location: Tate Gallery, London, Great Britain. Courtesy Tate, London/Art Resource, NY.

The Artist's Mother

Picasso, Pablo. *Portrait of the Artist's Mother*, 1896. © 2008 Estate of Pablo Picasso / Artists Rights Society (ARS), New York.

Picasso, Pablo. *Portrait of the Artist's Mother*, 1923. © 2008 Estate of Pablo Picasso / Artists Rights Society (ARS), New York.

Picasso, Pablo. *Mother and Child*, 1921–2. © 2008 Estate of Pablo Picasso / Artists Rights Society (ARS), New York.

Umberto Boccioni, *Materia*, 1912 (reworked 1913). Oil on Canvas, 226 x 150 cm. Courtesy of the Gianni Mattioli Collection (on long term loan at the Peggy Guggenheim Collection, Venice).

Umberto Boccioni, *The Artist's Mother*, 1915. Pencil and watercolor washes on paper. 65.1 x 53 cm. © The Metropolitan Museum of Art/Art Resource, NY.

Giorgio de Chirico, *Portrait of the Artist and His Mother*, 1919. Oil on canvas. Location: Musee National d'Art Moderne, Centre Georges Pompidou, Paris, France. © 2008 Artists Rights Society (ARS), New York / SIAE, Rome. CNAC/MNAM/Dist. Réunion des Musées Nationaux/Art Resource, NY

Arshile Gorky, *The Artist and His Mother*, ca. 1926–1936. Oil on canvas, 60 x 50 inches. © 2008 Artists Rights Society (ARS), New York. Image courtesy Whitney Museum of American Art, New York; gift of Julien Levy for Maro and Natasha Gorky in memory of their father.

Arshile Gorky, *The Artist's Mother*, © 2008 Artists Rights Society (ARS), New York.

Frida Kahlo, *My Grandparents, My Parents, and I (Family Tree)*, 1936. Oil and tempera on metal panel, 12 1/8 x 13 5/8. Location: The Museum of Modern Art, New York, NY, USA. Digital image © The Museum of Modern Art/Licensed by SCALA/Art Resource, NY.

William H. Johnson, *Mom and Dad*, 1944. Oil on paper board, 31 x 25 3/8 inches. Gift of the Harmon Foundation. Location: Smithsonian American Art Museum, Washington, DC, USA.

Alberto Giacometti, *The Artist's Mother*, 1950. Oil on Canvas, 35 3/8 x 24. Location: The Museum of Modern Art, New York, NY, USA. © 2008 Artists Rights Society (ARS), New York /ADAGP / FAAG, Paris. Digital image © The Museum of Modern Art/Licensed by SCALA/Art Resource, NY.

Andy Warhol, *Julia Warhola*, 1974. © 2008 The Andy Warhol Foundation for the Visual Arts / ARS, New York.

Paul Davis, *Untitled Watercolor*, 1968. Used with permission of the artist.

Index of the Artists